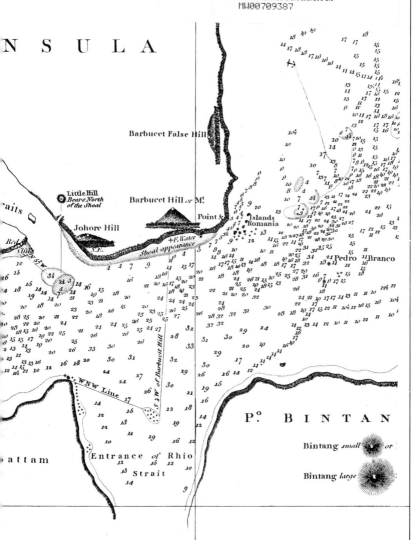

N S U L A

Barbucet False Hill

Little Hill
Bears North
of the Shoal

Barbucet Hill or M.t

raits

Johore Hill

Point

Islands
Romania

F. Water

Shoal appearance

WNW Line

Entrance of Rhio
Strait

P.o B I N T A N

Bintang *small* or

Bintang *large*

attam

Pedro Branco

IMAGES OF ASIA
Series Adviser: SYLVIA FRASER-LU

Old Singapore

Titles in the series

At the Chinese Table
T. C. LAI

Balinese Paintings (2nd ed.)
A. A. M. DJELANTIK

Bamboo and Rattan:
Traditional Uses and Beliefs
JACQUELINE M. PIPER

The Birds of Java and Bali
DEREK HOLMES and
STEPHEN NASH

The Birds of Sumatra and
Kalimantan
DEREK HOLMES and
STEPHEN NASH

Borobudur (2nd ed.)
JACQUES DUMARÇAY

The Chinese House: Craft,
Symbol, and the Folk Tradition
RONALD G. KNAPP

Chinese Jade
JOAN HARTMAN-GOLDSMITH

Early Maps of South-East Asia
(2nd ed.)
R. T. FELL

Folk Pottery in South-East Asia
DAWN F. ROONEY

Fruits of South-East Asia: Facts
and Folklore
JACQUELINE M. PIPER

A Garden of Eden: Plant Life in
South-East Asia
WENDY VEEVERS-CARTER

The House in South-East Asia
JACQUES DUMARÇAY

Images of the Buddha in Thailand
DOROTHY H. FICKLE

Indonesian Batik: Processes,
Patterns and Places
SYLVIA FRASER-LU

Japanese Cinema: An Introduction
DONALD RICHIE

The Kris: Mystic Weapon of the
Malay World (2nd ed.)
EDWARD FREY

Life in the Javanese Kraton
AART VAN BEEK

Macau
CESAR GUILLEN-NUÑEZ

Mammals of South-East Asia
(2nd ed.)
EARL OF CRANBROOK

Mandarin Squares: Mandarins
and their Insignia
VALERY M. GARRETT

The Ming Tombs
ANN PALUDAN

Musical Instruments of
South-East Asia
ERIC TAYLOR

Old Bangkok
MICHAEL SMITHIES

Old Manila
RAMÓN MA. ZARAGOZA

Old Penang
SARNIA HAYES HOYT

Old Singapore
MAYA JAYAPAL

Sarawak Crafts: Methods,
Materials, and Motifs
HEIDI MUNAN

Silverware of South-East Asia
SYLVIA FRASER-LU

Songbirds in Singapore:
The Growth of a Pastime
LESLEY LAYTON

Traditional Chinese Clothing in
Hong Kong and South China
1840–1980
VALERY M. GARRETT

Old Singapore

MAYA JAYAPAL

SINGAPORE
OXFORD UNIVERSITY PRESS
OXFORD NEW YORK
1992

Oxford University Press

Oxford New York Toronto
Delhi Bombay Calcutta Madras Karachi
Petaling Jaya Singapore Hong Kong Tokyo
Nairobi Dar es Salaam Cape Town
Melbourne Auckland
and associated companies in
Berlin Ibadan

Oxford is a trade mark of Oxford University Press

© *Oxford University Press Pte. Ltd. 1992*

Published in the United States by
Oxford University Press, Inc., New York

ISBN 0 19 588552 X

British Library Cataloguing in Publication Data

Jayapal, Maya
Old Singapore.—(Images of Asia)
I. Title II. Series
959.57
ISBN 0–19–588552–X

Library of Congress Cataloging-in-Publication Data

Jayapal, Maya, 1941–
Old Singapore/Maya Jayapal.
p. cm.—(Images of Asia)
Includes bibliographical references and index.
ISBN 0–19–588552–X:
1. *Singapore—Social life and customs. 2 Singapore—History.*
I. Title. II. Series.
DS609.9.J39 1992
959.57—dc20
91–29360
CIP

Printed in Singapore by Kyodo Printing Co. (S) Pte. Ltd.
Published by Oxford University Press Pte. Ltd.,
Unit 221, Ubi Avenue 4, Singapore 1440

For my parents,
who taught me to appreciate
the written word,
and for my husband,
who encouraged me to set it down.

Preface

THE history of a city is always fascinating because it carries with it not only accounts of events which have led to its conception and growth, but also chronicles of the people who have made the city what it is today and who have given it its identity and sense of belonging so that it is a live and pulsating place, not just a dot on a map.

This book describes, within the time-frame in which it is set—c.1819–1914—the communities which have given Singapore its multiethnic distinctiveness, including their patterns of migration, mode of life, dress, and focal buildings.

Obtaining these accounts has been both pleasurable and frustrating, pleasurable because it allowed me to indulge in my favourite pastime, reading, but frustrating because most of the accounts were by Europeans and were therefore, understandably, somewhat Eurocentric. I pored over the journals of travellers of the time, men and women who saw the country with fresh eyes, sometimes ecstatic, sometimes horrified, sometimes prejudiced when judging by the mores of their own environment. Despite these Eurocentric impressions, Singapore always had the last word, and it remains, in spite of the veneer, inarguably an Eastern town, as it was even a hundred years ago.

No book is the product of one person's effort. There is a need from others for advice, discussion, and criticism, and in my quest for materials I have been helped by many willing hands. Michael Sweet of Antiques of the Orient gave much of his time, enthusiasm, and effort in not just providing many of the illustrations but by always being ready to discuss a point and by reading the manuscript. Julia Oh deserves gratitude for constructive advice on the manuscript; Boruna Peerbhoy for the quotation on Raffles from Westminster Abbey and for

encouragement and advice; Nadia Wright for her prompt reply to my questions, and Judith Balmer for taking some of the photographs.

Special thanks go to Mr Ameen Ali Talib and Professor Yusuff Talib for information on the Arab community. The staff of the various institutions—the National Museum of Singapore, the National Archives of Singapore, and the National Library of Singapore—were also extremely helpful and patient.

I would like to mention the Friends of the Museum, the organization under the auspices of which I gave the talk for the celebration of its Centennial, which formed the basis for this book, and the editors of the Oxford University Press for encouraging and guiding me. And last but not least, all the other friends on whom I have from time to time relied for a shoulder.

The quotations at the beginning of the chapters have been taken from the *Handbook of 20th Century Quotations*, compiled and edited by Frank S. Pepper, and published by Sphere Books Ltd., London, 1984.

Singapore MAYA JAYAPAL
July 1991

Contents

Preface		*vii*
1	The Founding of Singapore	1
2	Singapore at the Turn of the Century	17
3	Life in Old Singapore	33
4	Transport in Old Singapore	57
5	Past Mementoes and Present Survivals	68
	Select Bibliography	78
	Index	83

I

The Founding of Singapore

In every man of genius, a new strange force is brought
into the world.

Havelock Ellis

HISTORY is often occasioned by a set of variable factors: fortui-
tous circumstances, a powerful motivation for prospects for
country or self, and the sagacity of one man or a group of men.
And once in a while, as in the case of Singapore, it is because of
a judicious blend of all three.

The history of Singapore, for popular consumption, has
always dated from 1819 when Thomas Stamford Raffles decided
on it as a settlement, but prehistoric Singapore was known as
early as AD 1330 when a Chinese traveller, Wang Da-Yuan,
referred to hostilities between Siam and Tan-ma-hsi (Tumasik).
The name Tumasik derives from *tasek*, meaning lake or sea, so
it might have meant island. There is also a reference to the
island by that name in the Wu Bei Zhi chart, compiled from
mariners' maps which combined the functions of charts, sailing
directions, and the routes of the Chinese Admiral Zheng He.
It has also been speculated that contact between China and
Singapore had been maintained even in the Sung dynasty
(960–1279) for then, as now, Singapore's strategic position on
the high seas was significant.

The name Singapura or Simhapura first appeared in the
Sejarah Melayu (Malay Annals) which was written in AD 1535.
The legend attributes the name to Sang Nila Uttama, son of
Rajah Chulan of India and the daughter of the god of the sea,
who saw a beast on the island and mistook it for a lion. (*Singha*
in Sanskrit means lion and *pura* a town.)

Legends in the *Sejarah Melayu* also romanticize the early
founding of Singapore by a Sriwijaya prince, Sri Tri Buana,
who claimed ancestry from Alexander the Great. Tome Pires,

the Portuguese writer who listed Javanese informants as his sources some time in the early 1500s, attributed it to a renegade Palembang prince, Parameswara, who fled to Singapore. It was then called by its old name—Tumasik in old Javanese or Temasik in Malay. Parameswara later took the name of Iskandar Syah after his conversion to Islam, and it is his *kramat*, or shrine, that is on Fort Canning Hill. However, a tide of events washed over the port in the form of conquest by the Madjapahits, attacks by the Siamese, and, finally, ransacking by the Portuguese in the early seventeenth century. Then Singapura, as it was known at that time, reverted to the jungle, with obsessive silent mangrove swamps of the type sketched by Ransonnet (Colour Plate 1), and sparsely peopled by the Sea Gypsies, the colourful name given to the Orang Laut, a generic term encompassing different tribes who claimed ancestry from the Sakai hill tribes in the Riau–Lingga archipelago. Their transition to the water probably occurred after the thrust of Malay migration. It needed Raffles to propel Singapore into the limelight in the early nineteenth century.

If the history of early Singapore could reflect the biography of any one man, it would be that of Raffles (Plate 1). The tribute written in black capitals on gleaming white marble under his bust at Westminster Abbey says that

he founded an emporium in Singapore
where in establishing freedom of person as the right of the soil
and freedom of the trade as the right of the port
he secured to the British flag
the maritime superiority of the eastern seas.
Ardently attached to science
he laboured successfully to add to the knowledge
and enrich the museums of his native land.
In promoting the welfare of the people committed to his charge
he sought the good of his country
and the glory of God.

Raffles' birth was a fitting herald of things to come. It occurred far away from home, three or four days out of Jamaica, on a West Indiaman captained by his father. The

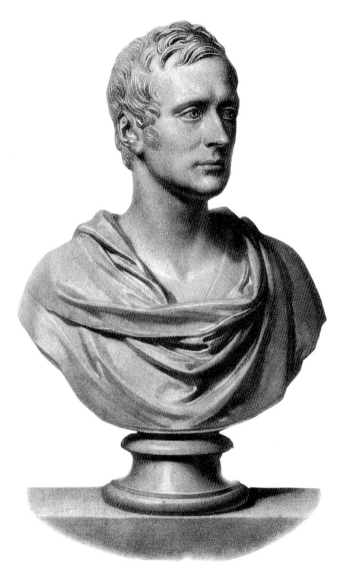

1. Bust of Sir Thomas Stamford Raffles, from *Memoir of the Life and Public Services of Sir Thomas Stamford Raffles*, by Lady Raffles, London, 1830.

young boy was propelled early into the working world due to straitened circumstances. He entered the East India Company at the age of fourteen, but in his own words (quoted in Makepeace et al., 1921), 'the dry drudgery of the desk's dead wood' could not contain him, and by a blend of assiduous work, avid interest in everything around him, and foresight, he got posted to Penang in 1805 and then later to Java.

While in the East, he saw and was alarmed at the increasing Dutch supremacy in the region. He convinced Hastings, the then Governor-General in India, that it was imperative for the British to establish a settlement at the eastern end of the Malacca Straits to prevent the hegemony of the Dutch. It was here that chance played a part in pointing to Singapore rather than to his other two choices of the Carimon Islands and Riau (west and south of Singapore, respectively) as an excellent site for founding a 'factory'. On 28 January 1819, the *Indiana*, carrying Raffles, anchored off St. John's Island close to the mouth of the Singapore River.

An eyewitness account by Wa Hakim, one of the local Orang Laut, describes the scene which met Raffles: there were under 300 small houses and huts at the mouth of the River and about thirty families of Orang Laut lived in boats at the wide part of the river, a little way up. The numbers probably grew in Wa Hakim's memory with the passage of time as he was but a stripling when Raffles landed. At the time of Raffles' landing they were encamped near the mouth of the river under their *batin*, or chief, the Temenggong of Johore. For the most part they lived in boats, eking out an existence by making *kajang*, or palm frond mats, and boat sails.

In his magnum opus, *The Hikayat Abdullah* (The Autobiography of Abdullah Kadir, first published in Malay in 1849), with superstitious horror Munshi Abdullah attributes fearful qualities to the Orang Laut and says that even the devils and jinn were frightened of them. His work contains a graphic description of the gruesome sight along the beach: 'All along the shore were hundreds of human skulls rolling about on the sand; some old, some new, some with hair still sticking to

them, some with the teeth filed and some without.' Though
the descriptions of the victims of these sea pirates may not have
been without exaggeration, it is indeed true that they found an
easy mode of existence by resorting to piracy. Later accounts
even imply that the Temenggong himself encouraged these
buccaneering piratical forays and the British had to work hard
to make Singapore a safe place for foreign ships to land.

Abdullah's description portrays the right bank of the river,
on which was later established Commercial Square, as a hilly
jungle leading to marshy land, totally uninhabited. On the
other side, there was also jungle, but it was interspersed with
clusters of huts and the ubiquitous coconut palms. It is difficult
to envisage this palimpsest of Singapore, accustomed as we are
to a thriving bustling scene characterized by frenetic activity
among people, vehicles, and goods.

Raffles, realizing the expediency of settling the lease of
Singapore, pushed to formalize it. Initially, the Temenggong
was reluctant to accede to Raffles' request for speedy action, for
he said that the consent of the Sultan of Johore was necessary,
but this position was under dispute at the time, since the Sultan
had died two years ago leaving two contenders for the Sultanate.
The eldest son, Tengku Long, who was designated as next in
line, was away in Pahang for his marriage and his younger
brother, Abdu'r Rahman, had usurped his throne at the instiga-
tion of their uncle and with the approval of the Dutch. Raffles
had Tengku Long brought from Riau, where he had gone to
live, to sign the treaty which gave the East India Company the
right to maintain a settlement in return for an annual allowance
of 5,000 Spanish dollars to Long and 3,000 to the Temenggong.

The scene on the morning of 6 February 1819, when the
treaty to lease Singapore was formalized, heralded British
pomp and ritual which would characterize Singapore cere-
monies in the future. The major dignitaries were present: the
Temenggong, Tengku Long, also known as Sultan Hussein,
whose cause in the succession to the Sultanate of Johore opera-
tion was espoused by the British, Colonel Farquhar, a close
friend of Raffles, with years of administrative experience in

Malaya, and Raffles. All the panoply was observed: the red carpet, the military guard, the buntings, the guns, and the raising of the Union Jack. Thus the two dates, 28 January and 6 February, became the rubrics of the year 1819.

Donald and Joanna Moore (1969) quote Raffles' jubilant words in a letter to his friend, William Marsden, in February 1819, on his own selection of Singapore as a trading and provisioning port: 'In short, Singapore is everything we could desire, and I may consider myself most fortunate in the selection; it will soon rise into importance and with this single station alone would I undertake to counteract all plans of Mynheer; it breaks the spell; and they are no longer the exclusive sovereigns of the Eastern seas.'

Like the Spaniards who built Manila in the image of their own cities, Raffles incorporated many elements from the British policies in the Indian colonies when he planned the city. But unlike the Spaniards who pushed for a fortified city to repulse attacks from the Chinese and the Dutch, Raffles' plans reflected his dreams of a trading city, and he made nominal provision for defence. Had the Dutch Governor Van der Capellan attacked Singapore immediately, the city would almost certainly have had to capitulate. But by another quirk of fate, which was in Raffles' favour, Capellan was so sure that Hastings would abjure Raffles' act in signing a treaty with a person the British Government did not consider the legitimate heir to the Johore ascendancy, that he never thought of attack.

Raffles' instructions to Farquhar, whom he established as Resident, display his precise intentions. They laid the blueprint for the master plan which would later give rise to this description by a taxidermist and collector of natural history specimens by the name of William Hornaday in 1885: 'Singapore is certainly the handiest city I ever saw, as well planned and carefully executed as though built entirely by one man. It is like a big desk, full of drawers and pigeon-holes, where everything has its place, and can always be found in it.'

Raffles used the natural lie of the Singapore River to demarcate the land, the demarcations being based on race and vocation.

At the time, the boundaries were Tanjong Katong in the east and Tanjong Malang in the west and it extended inland 'as far as a cannon shot could be heard'. He designated the area north of the River for the cantonment and official buildings, along with the Temenggong's camp which was already there. East of the official quarter came the official European residences. Extending beyond these was to be the residential quarters for the Sultan and his followers, known as Kampong Glam from the Glam tree, or *kayu puteh*, which provided the economic basis for these early dwellers. He allotted the marshy south bank of the Singapore River to the Chinese with a bridge to join the two sides. The commercial section was to be along the east coast. At this time, the pivotal element was still the cantonment, including the Sepoy Lines to house the soldiers, where the General Hospital now stands, and the parade ground—the Plain—very similar to the plans followed in British India, as shown in this description written by an officer, Forbes, about the Bengal Cantonments near Surat (1783) and quoted in Yule and Burnell's *Hobson-Jobson* (a compendium of colloquial Anglo-Indian words and phrases): 'I know not the full meaning of the word cantonment, and a camp this singular place cannot well be termed; it more re-sembles a large town, very many miles in circumferance.' The 'cantonment' was really a permanent military camp, with facilities for accommodation for officers and men, a garrison church, and a huge open plain for manoeuvres. This plan greatly influenced the settlement patterns of all urban colonies of the British.

The peopling of the town was done with great deliberation. Raffles and Farquhar invited immigrants to settle in specially designated areas and laid the basis for the different kampongs (or settlements) which sprang up, such as Kampong Bugis, Boyan, Melaka, and Melayu. The Bugis came, with their elegant distinctive craft, the *panisi*, and though they were warlike and quarrelsome, their flamboyant arrival was looked forward to by the locals. But they tamed themselves, got rid of their aggressive instincts, and settled down as traders. Other

immigrants included the Armenians, the Arabs, and the Indians. The European merchants also came, fired by the dream of 'gold coming up from the ground' and each ethnic group added its singular tint to the landscape.

When apportioning land to the different communities, Raffles kept their vocations in mind. He distinguished between short-term traders and merchants, fixed strategic sites for the residences of the chiefs of the various races who would maintain order and discipline, and saw to it that the roads in the Bugis kampong were directed to the river. The Arabs were located in the vicinity of the Sultan's residence, the Indians where their services as traders and boatmen would be needed most, and the Malays near the upper banks of the Singapore River.

However, when Raffles returned in October 1822 he found that Farquhar, faced with some unexpected problems, had acted on his own initiative. The earliest godowns or warehouses (Colour Plate 2) were sited on the Chinese south bank instead of on the east coast which was found to be unsuitable as a landing area because of the shallowness of its waters. But Raffles did not take a tolerant view of what he felt was a flagrant violation of his explicit wishes and ultimately Farquhar resigned. With the help of Lieutenant Jackson, the Garrison Engineer, Raffles then set out the plan which in its basic elements still exists (Plate 2). However, several changes were implemented as Coleman's map of the actual survey of the town published in 1839 shows (Plate 3). Raffles specified areas for government buildings, religious worship, education, and also the size of the houses, the width of the streets, and the materials to be used. Using all his resources of persuasion, intimidation, and recompense he succeeded in shifting the Temenggong's overgrown village, which was causing disturbances in the heart of the government area, to the west coast, from Tanjong Pagar to Telok Blangah.

He then created Commercial Square, or Raffles' Place, to the south of the River by levelling a hill. The Square was to become the economic hub of the state where important trading houses were located. John Cameron, the proprietor–editor of

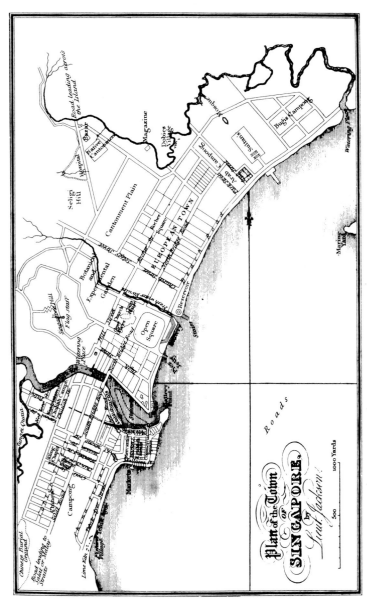

2. Plan of the town of Singapore, by Lieutenant Jackson, 1823.

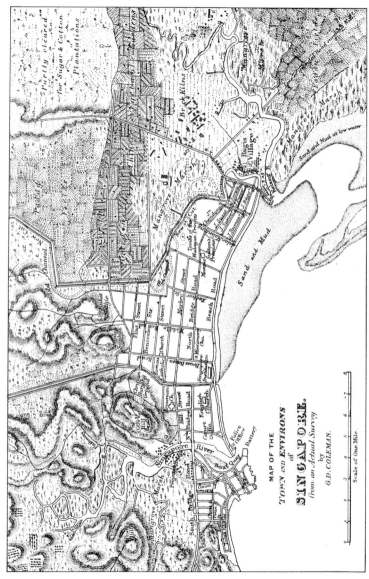

3. Map of the town and environs of Singapore from an actual survey, by G. D. Coleman, 1839. Courtesy Antiques of the Orient.

the *Singapore Free Press*, in a later description (1865) paints a pleasing picture of the Square. 'It is built round a reserved piece of ground, turfed over with green sod and tastefully laid out with flowers and shrubs, which afford to the eye a pleasing relief from the glare of the whitewashed walls of the square, while the open space ensures good ventilation to the neighbourhood.'

Postcards from the late 1800s (Plate 4) show tired ponies tethered to shade-giving Flame of the Forest trees waiting for their 'mems' (an Anglo-Indian word for mistress) to finish their shopping or other business, for here were concentrated the telegraph office, banks, godowns of old trading companies, and shops such as Robinson's. The back doors of old godowns faced the sea to facilitate loading and unloading of goods. Horses were also periodically auctioned in this square.

The mix of houses, godowns, and mercantile establishments, mostly built of brick with plaster, presented an eye-catching sight. Especially dramatic was the crescent formed by the long range of godowns. This crescent, which came to be known as Boat Quay because of the loading and unloading of various boats in front of it, arose as an adjunct of the Square since the earth from the levelled hill was used to form it. Later the Chinese would call it, appropriately enough, Bu Ye Tian ('place of ceaseless activity'). But Cameron was more transfixed by the Chinese quarter, which seemed more colourful, especially on festival days when the 'turkey red cloth' was billowing in the wind, and at night when all the veranda windows were lit up with multicoloured Chinese lanterns which were reflected in the waters.

On the fringe of the Chinese area were De Souza Street, Market Street—the barometer of trade—and Chulia Street, often called by the Chinese Hua Hooi Kak, or 'flower garden corner'.

Raffles was also responsible for the five-foot ways which front the narrow deep terraced houses and which are a distinctive feature of Singapore architecture. They were, and still are in

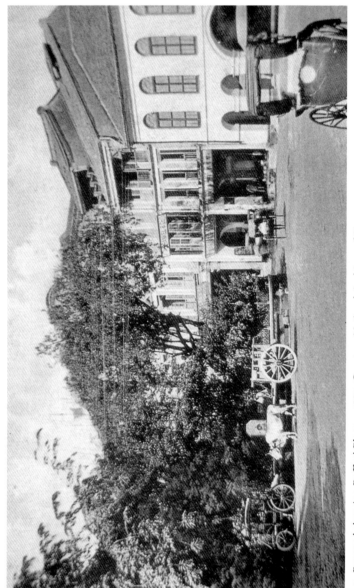

4. Postcard showing Raffles' Place, c.1880. Courtesy National Archives of Singapore.

some areas, a focus of life and trade. They run like a continuous route in front of the houses, serving as a shelter from the inclemencies of the weather and occasionally as venues for trading or hawking. Here were found a veritable profusion of minor traders: the letter-writers who wrote all kinds of documents including suicide notes for the illiterate, fortune-tellers, *bomohs* (or medicine men) who sold home-made medicines and advised on treatment for both spiritual and physical ailments, beauticians who listed as their duties forehead shaving, pigtail braiding, and ear cleaning, barbers and cobblers, seamstresses and knifesharpeners, travelling foodsellers, pot menders, and locksmiths. Some of these may still be found in certain areas.

However, the Hill remains the core of historical and archaeological interest, even now, when bulldozers are tearing into its green swards for renovation, and buildings have come up to replace old sites. An air of mystery overhangs it in the early morning when the machines are at rest and the cicadas and the golden orioles hop about as they did more than a century ago. Variously known as Bukit Larangan, or the Forbidden Hill, because of the awe with which the Malays regarded it, then as Government Hill and Bukit Bendera, or Flag Hill, because of the signal for approaching ships, it finally got its present name, Fort Canning Hill, in 1860, after the then Governor-General of India, Viscount Canning. It still retains a commanding view of the surroundings, looking down at the magnificent harbour which formed the focus of the entrepôt trade which has made Singapore renowned.

In 1822 John Crawfurd, author of a *History of the Indian Archipelago* and the Resident of Singapore after Raffles' departure in 1823, noted on the Hill a square terrace with fourteen large sandstone blocks which have since disappeared, enclosing a hollow which he conjectures could have been a place of worship, a temple of Buddha. John Miksic, historian and archaeologist (1985), says that it 'may have been either a sanctuary or a roofed hall with wooden pillars and open sides, the *balai* of classical Indonesian architecture'. This was roughly on the spot which is now the Lookout. The Forbidden Spring,

or Pancur Larangan, lay on the west side of the hill and was presumably used by the women of the royal household. This romantic spot now houses the prosaic municipal swimming-pool.

The Hill also houses the *kramat* of Iskandar Syah (Plate 5) and the inscription on the plaque proclaims that 'Traditional Malay chronicles state that the last king of the Malays Sri Tri Buana and his Chief Minister Demang Labur Duan were buried here'. The *kramat* retains its hallowed air, with burning incense and flowers and other offerings placed there by the caretaker. The pigeons flock there cooing and pouting and pecking the grain thrown by visitors to the shrine despite the sign which says 'Feeding of pigeons is prohibited'. The number of pilgrims who still come there testifies to the sanctity of the site.

5. *Kramat* of Iskandar Syah on Fort Canning Hill, 1991. Photograph Judith Balmer.

There was an old cemetery on the Hill where under the green grass lie many an illustrious name that played a significant role in the administration of the Settlement. Now only a few tombstones are left standing. The rest, with their inscriptions, have been embedded in the wall which surrounds it leading up to the Fort Canning Centre.

Crawfurd also saw 'the durian, the rambutan, the duku, the shaddock and other fruit trees of great size'—a corroboration of Munshi Abdullah's mention of a garden, or *taman*, on the lower slopes of the Hill.

Farquhar's temporary house when he was Resident was on the Padang, or square, near where the cricket pavilion is now, but Raffles preferred the Hill (Colour Plate 3). His choice was probably induced by its strategic location, commanding, as it did, a fine view, but it was also open to the cool breezes which must have been balm to the cares of a man founding and running a settlement. It appears from Raffles' own version that the verdant slopes exercised a strange fascination for him and he seems to have wanted to be buried along with the Malay kings. In a letter to Marsden in 1823 he says that 'Nothing can be more interesting and beautiful than the view from this spot.... The tombs of the Malay kings are however, close at hand; and I have settled that if it is my fate to die here, I shall take my place among them: this will, at any rate, be better than leaving one's bones at Bencoolen ...' (cited by Pearson in *JMBRAS*, Vol. XXV, Pt. 1).

It was wise of Raffles to choose a Malay style house of *atap*, or palm frond, and wood for it was an ideal architectural model for the hot, humid tropics. It incorporated the Anglo-Indian elements of long verandas to catch the sea breezes, which helped to ameliorate the humidity and harshness of the tropical sun. At first it was considered to have been a ramshackle, rather insubstantial structure. According to an early traveller, George Windsor Earl (1837), it was so flimsy as to cause apprehension about whether it would withstand the frequent Sumatra squalls which shook the region, and people often looked upwards to see if it were still standing. He also talked of

the reed thatch which harboured all sorts of lizards and insects.

For about forty years, during which many additions were made to the house, it continued to be the Governor's Residence. Later it became an Artillery Barracks, and on the southern summit at a height of 156 feet above sea level were constructed a signal station, a flagstaff, and light tower. From here resounded the sound of guns at 6 a.m. and 12 noon, and also fire signals and shipping signals. In the 1860s, Cameron described the Hill thus: 'But most prominent in the background is the hill on which Fort Canning has been constructed and which rises up abruptly about a quarter of a mile inland from the beach; it is almost pyramidal in shape, covered from its base up to the ramparts with beautiful green turf, and crowned with a cluster of thick foliaged trees, through which the garrison buildings can show their white walls and red roofs. Here too is erected the town flagstaff, kept pretty constantly busy signalling the daily arrivals in the harbour.' The Fort Canning Light was extinguished in 1958, after more than a century of yeoman service guiding ships into Singapore.

Raffles, an archetypal Renaissance man with an avid interest not only in all aspects of Eastern culture and literature but also in anything that grew or wriggled, laid out a spice garden of clove and nutmeg trees on the slopes. This was the germ of the idea of the present lush Botanical Gardens at Cluny Road. He also asked Dr Nathaniel Wallich, a revered Danish surgeon from Calcutta, for 200 head of spotted deer.

Singapore's other European inhabitants did not follow Raffles' modest idea of a residence but favoured spacious houses on the plain facing the sea across the Esplanade or the Padang. As Colonel Nahuijs, a Dutch visitor, remarked in 1824, 'Singapore can already boast of thirty tastefully built European houses. These are placed a short distance from one another and in front of them runs a carriage-way, which they all make use of in the afternoons.'

After this auspicious start engendered by Raffles, Singapore grew by unprecedented leaps and bounds, and the world sat up and took notice.

2

Singapore at the Turn of the Century

> One might regard architecture as history arrested in stone,
> the movement of time congealed ... at every point a
> building expresses the needs, the character of its age.

<div align="right">A. L. Rowse</div>

As much as anything else, Singapore's road names reach back
into the past. Some commemorate a historical event, for ex-
ample, Waterloo, Somme, Flanders, and Verdun Streets. Others
are overt expressions of gratitude to men and women of stature
and consequence, both local and foreign, who have quarried
their experience for the benefit of Singapore, like Chong Hong
Lim Street after the philanthropist founder of Hong Lim Green,
Coleman Street after a famous architect, Thomson Road after
the Government Surveyor, and D'Almeida Street after the
colourful Portuguese doctor, merchant, and agriculturalist who
stopped off in Singapore in 1825 and made it his home.

The different ethnic groups who have made Singapore their
home have also left their mark in the areas they used. Street
names of Armenian origin are Armenian Street, St. Gregory's
Place, Narcis Street, Parsick Hill, and Galistan Avenue, the last
three having been demolished. Jewish Street names like Belilios
Lane, Elias Road, Nathan Road, Meyer Road, and Nassim
Road testify to the stature of these people in the community,
while the Eurasians left behind their names in Tessensohn
Road, Desker Road, and De Souza Street.

Sometimes a historical landmark lends itself to a name: Fort
Road signified the presence of the old fort which had intriguing
moss-shrouded tunnels. The Tanjong Katong Park now covers
this area.

Still others were representative of trades and activities and this
is where it is evident that even if the British tried to impose

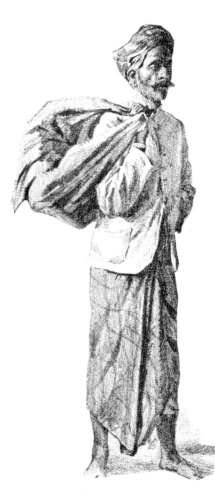

6. Indian dhobi, by Hugo V. Pedersen, from his *Door den Oost-Indischen Archipel*, 1908. Courtesy Antiques of the Orient.

their norms of solidity and reliability by the names they chose, such as Albert Street and Victoria Street, the inhabitants took over in naming them in their own picturesque tongues. Dhobi Green was the habitat of the dhobis, the Indian washerfolk, the forerunners of the more sophisticated dry-cleaners of today (Plate 6). There are also Artillery Avenue and Bras Basah Road. The latter was originally called College Road because of the Singapore Institution, but according to George Norris, writer and journalist (1878), it obtained its present name, Bras Basah (meaning 'wet rice') because of a cargo of rice which got wet due to a boat overturning in the creek and was spread out there to dry. Kampong Tempe in the Bukit Timah area refers to the fermented bean curd made there, and Kampong Roko derived its name from the collective task of the inhabitants of rolling cheroots (from *roko*, to smoke). This area disappeared with the construction of Kallang airport. No wonder Hornaday remarked: 'Owing to this peculiar grouping of the different trades, one can do more business in less time in Singapore than in any other town in the world.'

True also to the catholicity of religious expression, there is

Mosque Street, Synagogue Street, Church Street, and Pagoda Street.

Local people found it easier to identify names of streets according to trades or simple geographical positions. South Bridge Road was called Kalapithi Kadei Sadakku ('cawker's shop street') by the Tamils and Hokkien Street, Cho Be Chia Koi ('street where horse carriages are made') by the Chinese. Havelock Road was referred to by both Chinese and Tamils as Masak Arak Sadakku ('arrack distilling street') in an interesting mixture of Tamil and Malay. Some names referred to identifying landmarks: Commercial Square in Tamil was Kidangu Thiruvu or 'street of the godowns' while Alexandra Road in Chinese was Lau Chi Kha or 'foot of the betel nuts'. China Street became Kian Keng Chen or 'front of the gambling houses'. Boat Quay had several interesting names: Tiam Pang Lo Thau ('place to go for sampans'), Chap Poet Heng ('the eighteen houses'), Chwi Chu Boi ('bathing house end'), or Bu Ye Tian ('place of ceaseless activity').

The shape could also influence a name: Pulau Bukom, where the Shell refinery is, got its name from the shell *rangkek bukom* which it resembles. Or the name could have given an identity to the migrant communities who constituted the diverse social milieu that is Singapore, for instance, Parsi Road, Chettiar Street, Chulia Street, Hindu Road, Arab Street, Armenian Street, Zion Road, Bali Lane, Bencoolen Street, and Bugis Street, among others.

The area near Orchard Road in the late 1800s was a haven of peace and tranquillity, with large nutmeg plantations which may have given it its name. The owners of these plantations gave their names to areas and roads here, such as Prinsep, Carnie (who by a simple manipulation of some vowels in his name became Cairnhill), Oxley, and Scott.

The origin of some names remains obscure: Sago Lane and Sago Street, which later had morbid connotations because of the funeral parlours and shops selling supplementary necessities like incense, candles, and paper effigies, did not seem to have any evidence of sago palms or sago manufacture.

Some areas are associated with legends. For example, Bukit Merah, which means Red Hill in Malay, originates from an interesting legend. A certain king who had been advised by a young boy to use a fence of banana stems to ward off the attacks of swordfish asked some soldiers to kill the boy because he was afraid of the boy's sagacity. But an old woman with long white hair conjured up a fountain spouting blood which so horrified the soldiers that they ran away. Part of this area was once known as Beehoon Plain because of the thin noodles left out to dry here; it was later called by the ignominious name Rubbish Plain because of its being used as a dumping ground.

Sometimes misnomers arose. Bukit Timah has shown no sign of any tin as its name indicates. Lavender Hill, on the other hand, was a jocular reference to the stench emanating from the market gardens lying on either side and the gasworks which was situated in the area.

Occasionally, with the irony peculiar to the human race, the name of one whose fame has waned is supplanted by another. Cursetjee Street, named after a Parsee gentleman who was a partner in John Little, became Wallich Road after Dr Nathaniel Wallich.

The town at the turn of the century afforded many scenic drives and walks, given the relative serenity of its verdant, lush landscape. One of the most charming drives was to the Gap, now the Kent Ridge campus, which was formed by the cleft in the hills about six miles out of the town on the southern coast of Singapore. One reached it by following the winding Buona Vista Road to a ridge where suddenly, on a sharp turn, one was presented with a panoramic view of the sea with innumerable islands and, studded in between, the curious domestic Chinese and Malay seagoing craft. The scene is eloquently described in Wright and Cartwright (1908): 'At sunset, when the outlying islands are silhouetted against a glowing background of gold, and the shadows begin to steal over the silent waters of the deep, the scene is one of exquisite and impressive beauty.'

The topography of Singapore was interesting to the eyes of many travellers. It was a series of little hillocks around which

wound spiral drives. The inhabitants were seen to get into their carriages or on their horses and meander through them, revelling in the pretty, shady quays, avenues, the fine public buildings, and the whitewashed houses of the residents nestled in large compounds among shady trees on little hills to catch the breezes. If they drove out of town to Bukit Timah, they would glimpse quaint Malay and Chinese villages among the large plantations of pineapple, rubber, or coconut. For the European, accustomed as he was to the chocolate-box prettiness of the scenery of home, this would have been a startling change: the high trees, entwined by creepers, strange odours assailing the nostrils, the singular shapes of variegated palms, the betel-nut with its orange-red fruit, the ubiquitous banana and coconut trees, the fragrant nutmeg, and everywhere the jungle, barely kept in check. He would have been fascinated by the immense palms, the tracery of ferns, and the Traveller's Palm with its unmistakeable shape and its singular feature of storing moisture which spurts out from pockets at the base when these are slashed. The exotic flowers must have looked as vibrant as their names sounded: the ixora, the euphorbia, the scarlet hibiscus, and of course, everywhere, the blaze of the bougainvillaea.

It is perfectly understandable, therefore, that Singapore was considered the convalescent ground for invalids from the Indian colonies. Dr Thomas Oxley, the surgeon after whom the road was named, advised in the 1840s: 'So far the Invalid can enjoy the best exercises for the recovery of health, in occasional boating, or riding and driving in the open air during the cool mornings and evenings which he can remain out with perfect safety until 7 o'clock unless on some particularly hot morning' (in Wise and Wise, 1985).

Both the Botanical Gardens and the Thomson Reservoir appealed to nature lovers. The former were tastefully laid out with many tropical trees and flowers (Plate 7) and, at one time, boasted birds and beasts which included a rhinoceros, sloth bears, monkeys, kangaroos, and even a tiger. Wright and Reid (1912) describe the roads in the neighbourhood of the Gardens

7. Botanical Gardens, *c.*1910. Courtesy Botanical Gardens of Singapore Library.

where the visitor 'will be entertained by the antics of the gibbering monkeys as they spring from branch to branch of the trees overhanging the roadway'. On full moon nights, a band sometimes played in the Gardens, and the scene became transformed into a social evening, much like the evenings spent at the Padang. The Reservoir grounds had a well laid-out promenade with an outstanding view of the water.

People could also drive through Orchard Road itself, with its large imposing plantations, banked by tall bamboo hedges and the elegant Angsana trees. Or they could take a pleasant excursion by boat around the island to see the outline from a distance and be soothed by the rhythm of the wind and the sea, unhurried and languorous. Guided tours are being conducted even now, but these are more an attraction for tourists, than the pleasant pastime they were then.

A drive in a motor car in the early 1900s from the town to the Woodlands area would have been equally delightful, with the lights of Johore Bahru twinkling in the distance, and if there were festivities, there would be rockets and Chinese and Japanese lanterns to provide a fairy tale spectacle.

G. M. Reith in his *Handbook to Singapore* (1892) says: 'There is more than one road to town from all the wharves, but the best is that skirting the shore, because of the cool breeze from the sea, and also because the road leads straight to the business part of the town.' This road proceeded to Collyer Quay, then past the big offices, crossing the Singapore River by the Cavenagh Bridge to the Esplanade, to the left of which the visitor could see the imposing government edifices. This was encircled by a well laid-out carriage drive. He would admire the fine statue of Raffles, erected in 1887, in the centre. Then the road wound its way towards Fort Canning, curving past the Raffles Library and Museum, the Ladies' Lawn Tennis Club (where Dhoby Green was), the gate to Government House, and on to Orchard Road and thence the Botanical Gardens. He would get a fair idea of the layout of the city, its business, its residential, and its recreational centres. Another path rambled through Geylang Road, the first five or six miles of which were

very pleasant, after which it became uneven and serpentine.

The foliage, which most visitors still extol, was in a palette of greens from trees which often met in arched canopies affording shade and shelter. Most common were the beautiful Angsana trees with their glorious fall of golden blossoms and the Tembusu which filled the night air with their fragrance. George L. Peet, who has conveyed his impressions of Singapore life in the 1920s in his book *Rikshaw Reporter* (1985), comments that the nectar of these flowers attracted flying foxes which were caught by the Tamils and the Malays for their cooking pots. There was also the Cannonball tree with its exquisite white-starred flowers, but this is not so common now as its hard fruit is considered mildly poisonous. However, for the local people these trees had a function as well as a form: the wood of the Corintin was used for walking sticks, the hard wood of the Tembusu for chopping blocks, the Nibong for house-building, the Screwpine for *kajang* (mats) and basketry, the mangrove for firewood, and the Cannonball bark as a cure for dysentery.

For the enterprising visitor, who desired to delve a little deeper and explore the local scene, an excursion out to the Chinese, Malay, and Indian habitations must have been illuminating. John Turnbull Thomson, who served as architect, artist, and Government Surveyor in the 1840s, wrote: 'The Chinese part of the town was more compactly built upon, and resounded with busy traffic. The Malays lived in villages in the suburbs and their houses were constructed of wood and thatched with leaves.' Or the visitor could stroll around the main quay to watch Chinese and Malay high society, especially the beautiful ladies clad in their traditional cheongsam and *baju*.

Of course a great deal of riding was done and thus was Gallop Road named because it was an isolated stretch of road, conducive to just that—a gallop.

The Padang, then as now, formed the nucleus around which were grouped the buildings from which power was administered, the seats of justice and government, religion, and art. The equivalent of the green in England and the *maidan* in India,

the Padang was the hub of political, social, and cultural life. Called simply 'the Plain' by Raffles, it was a splendid open space cleared and levelled by Raffles' escort, Lieutenant Henry Ralfe. Since its foundation, it has hosted countless sports and ceremonies on its grounds during the New Year (which led to its being called the January Place by the inhabitants), resounded to ceremonial marches and parades, and welcomed the play of cricketers and tourists. Carriages rolled regally over its turf, when in the evening eligible young women could be glimpsed circumambulating in a stately turn or matrons observed exchanging the gossip of the day sitting in each other's carriages, while their husbands indulged in gentlemanly sports like cricket or discussed business (Colour Plate 4). 'Bengal Civilian' (Charles Walter Kinloch), a visitor to the island in the early 1850s, had this to say: 'Between the Esplanade and the beach is an enclosed space, within which all the beauty and fashion of the place promenade daily and enjoy the cool sea breeze. The scene is enlivened twice during the week by the regimental band, on which occasions the old women gather together to talk scandal, and their daughters to indulge in a little innocent flirtation.' On full moon day, following the Chinese New Year, Chinese maidens would make their presence known to eligible bachelors by appearing in their carriages. There was also an abandoned battery whose parapet was used to sit on, appropriately called Scandal Point.

The events of history are stamped on its green turf. It testified to the grim herding of the Europeans and others on its lawns in the sorrowful aftermath of the Japanese Occupation. It endorsed the surrender of these same Japanese troops on the steps of one of its silent sentinels, the City Hall. It remains a central focus of the island, hosting as it usually does, on 9 August each year, the National Day Rally, with its attendant pomp and ritual, in celebration of Singapore's independence.

The part of the Padang known as the Esplanade, which was originally only 70 yards wide, was partly enclosed in 1845 with posts and chains and later some trees. It was widened in the 1890s by land reclamation and fringed by shade-bearing trees

such as the Angsana and the Rain tree (which starts dripping moisture even before the rains). The statue of Raffles was in the middle of the Padang and there was a promenade which stretched through the centre connecting St. Andrew's Road (old Esplanade Road) and Esplanade Drive, which later became Connaught Drive in honour of the visit of the Duke and Duchess of Connaught in 1907.

Flanking it were buildings which bore the unmistakable stamp of one of the most influential of architects to shape Singapore's skyline—George Drumgold Coleman. Coleman, like many other architects of the time, had been considerably swayed by the dictums of classical Greek and Roman architecture and on these he superimposed the influences picked up from his stint in Calcutta. His entry into Singapore coincided with Raffles' vision of Singapore, of the transition of Singapore from a mere trading outpost into an elegant city which reflected the mores and values of British control and administration. His stylistic precepts are evident in the façades of many buildings, though most of these have vanished into the mists of time.

One of the buildings for which he was responsible was St. Andrew's Church. The talented Coleman constructed the first building, in 1835–6, in the Palladian style which became his hallmark, but due to the omission of the addition of the lightning conductors by Thomson, who was responsible for the tower and the spire, the church had to be pulled down and a second one built on its site, this time designed by Colonel Ronald Macpherson, who has an impressive memorial in its grounds topped by a Maltese Cross. It is said that he used the Gothic Netley Abbey in Hampshire as his model. The intrepid lady traveller Isabella Bird (1883) says that St. Andrew's was 'a fine colonial cathedral, prettily situated on a broad grass lawn among clumps of trees near the sea'.

Walking through the arched canopy of trees in the driveway the aura of peace and tranquillity that illuminates the cathedral is striking, and strolling through the spacious green grounds bounded by large trees, some of which have their aerial roots going deep into the soil, one can visualize in the late 1800s or

early 1900s the congregation arriving in carriages drawn by smart ponies and the crinolined and hooped ladies being handed down before the service. A bell which once belonged to the church underscores the American connection. Maria Revere, daughter of Paul Revere of American Revolution fame, who was the wife of the first American Consul in Singapore, presented the bell cast by her father. It was later transferred to the National Museum.

Coleman also laid his distinct impress on the elegant Armenian Church, the oldest one in Singapore.

At the turn of the century, the impressive frontage of the administrative buildings included the Municipal Building, now City Hall, the Victoria Memorial Hall and Theatre, and the old Hotel de l'Europe which occupied the site of the present Court House. The original Court House was the dwelling built by Coleman for John Argyll Maxwell, one of the first three magistrates appointed by Raffles, who unfortunately left for Scotland in the 1830s before he was able to grace the magnificent house constructed for him. There followed a dispute over the land rights to the house. It was used as a Court House for a while (Plate 8), but has finally found its niche as the Assembly House or Parliament House, guarded over by a bronze elephant presented by the King of Siam on his visit in 1872. Though very little remains of the original, it still reveals Coleman's distinctive influence.

Coleman also built the house which has been supplanted by the present Supreme Court and City Hall. It changed hands a few times, metamorphosing into the London Hotel, then the Hotel de l'Esperance, and, in 1865, into the famous Hotel de l'Europe with a roof garden and a renowned cuisine. The hotel had an impressive view of the Straits with its variegated shipping vessels, and one wonders if this was the Malabar Hotel referred to by Conrad in *Lord Jim*, from where he sees 'the riding lights of ships'.

Coleman was also responsible for the reconstruction of Raffles' vision for an institution of learning, the Raffles Institution, in 1837. The original building was on a plot of land

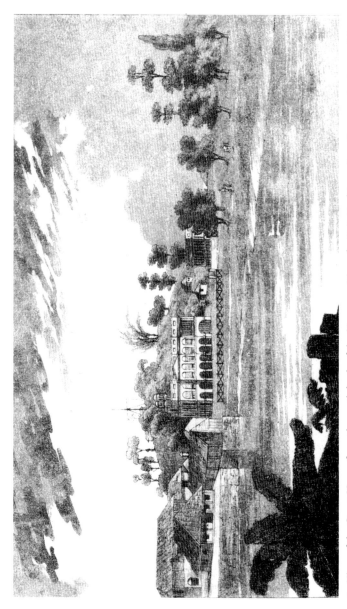

8. View of the Court House from the south bank of the Singapore River, by P. J. Begbie, c.1830. Courtesy Antiques of the Orient.

bounded by Beach Road, College Road (which became Bras Basah), Rochor Road (Victoria Street), and Stamford Road (Colour Plate 5). This graceful testimony to a man's breadth of view, with its arches so typical of Coleman's style, was demolished in 1972. On the original site now stands Raffles City.

Raffles now looks down complaisantly from two places on the humming hustle and bustle which he set in motion: one statue is in front of the Victoria Memorial Hall and Theatre, and the second, a replica of the first, was placed at Raffles' landing-place at the side of the Empress Hall buildings, in 1972.

It was around the turn of the century that many other buildings came up reflecting the changing face of society and the flowering of the local flavour. Among these were Tan Yeok Nee House (1885), which is now the Salvation Army Headquarters, with its distinctive roofs and curved eaves, the Thong Chai Medical Hall in Wayang Street, and the profusion of religious edifices such as the Hindu temples with their elaborate *gopuram* (gateways), the ornamental Chinese temples, the classic onion-shaped domes of the mosques, and the elegant church steeples and spires.

We should not forget the original General Hospital, built in 1882 on the site of the present one. Conrad was one of its illustrious inmates, having fallen ill on one of his voyages.

The construction of most of the public buildings was done mainly with convict labour, predominantly Indian. When the Anglo-Dutch Treaty was signed in 1824, about 200 convicts were transferred to Singapore from Bencoolen. These numbers were gradually swelled by the influx of convicts direct from India. Coleman employed them for both reclamation and construction. Major John McNair, who was the Superintendent of convicts as well as Colonial Engineer, describes the evolution of the administrative system used in their deployment: those who showed capabilities were given inducements of pay and perquisites to act as supervisors.

The convicts did yeoman service in Singapore, and were responsible not only for the construction of buildings but also

for much of the infrastructure of roads and bridges. With these convicts was borrowed another idea from India, the application of Madras *chunam* to plaster the walls of certain public buildings. This was an intriguing mix of shell lime without sand, egg white, *jaggery* or coarse brown sugar, and water in which coconut husks had been steeped. This was plastered on to the walls and polished to a sheen with a rounded stone. Against the backdrop of a tropical blue sky, the effect was dazzling.

Like the roads which linked areas, peoples, and vocations, many bridges were built with the same objective. Cavenagh Bridge, which was constructed in 1867 to commemorate the establishment of Singapore as a Crown Colony, served to soothe the vexation of those who had to pay a duit (a quarter cent) to cross to the Post Office or Master Attendant's office by ferry, and to link Commercial Square to the government areas. However, like many other bridges, it did not allow for boats to pass through at high tide. In 1910 it was also declared off limits to ox carts, horses, and vehicles exceeding a certain weight. It is now an elegant pedestrian bridge, though the sight which meets the eye from it is far removed from that which met Horace Bleackley's (1928): 'The bridge is a suspension bridge, narrow and inadequate, but the river that it spans is full of interest. It was the old harbour, and its left bank, which bends almost in a half-circle, is crowded with ancient Chinese houses. Of various elevations and in different styles of architecture, they appear to be painted in all the colours of the rainbow; and when the sun is revealing every line and shade of them, the curved frontage of the irregular buildings seem as complex and kaleidoscopic as a street in Venice.'

The other bridges of interest were Ord Bridge (1886), Read Bridge (1889), and Anderson Bridge, the last being built in 1909 to cope with the significant increase in the number of lighter barges. The oldest was the Elgin Bridge across the Singapore River, made of wood and joining North and South Bridge Roads. It was called Presentment Bridge when built by Lieutenant Jackson in 1822. The only bridge till 1840, it became

a footbridge in 1844 when it was renamed Thomson's Bridge. In 1846 it was widened to allow horses and carriages. It was demolished in 1862 and in the next year an iron bridge was imported from Calcutta to take its place and this was called Elgin Bridge (Colour Plate 6).

The markets were a teeming hub of colour. They were five in number and were the focal points for the distribution of fresh fruit and vegetables. The most famous, the Telok Ayer, with its unique octagonal structure, first erected in 1820 and then enriched by cast iron imported from Scotland in 1894, was noted for its cleanliness. The others were the Ellenborough, the Rochore, the Clyde Street, and the Orchard Road markets.

The harbour was like a microcosm of the colour and the *mélange* that constituted the people of Singapore town. Charles Wilkes, Commander of an American exploring expedition between 1838 and 1842, describes the scene: 'The Chinese junks exhibited their arched sides painted in curved streaks of red, yellow, and white; the Siamese ships, half European in structure and model, showed huge carved sterns, and these were contrasted with the long, low, and dark hulls of the prahus and the opium-smuggler' (Colour Plate 7).

There was also constant traffic amongst the various small boats which ferried goods and passengers to and from the seagoing vessels. And the romance of the sea lay in their names: *sampan* (keelless boats made of three planks which gave it its name in Chinese), *tongkang* (lighters), *kolek* (keeled small boats used by the Malays), *lepap* (used as ferries) and, *prahu*, *kwa tow*, as well as the boats of the Indonesian islands, the *palari* or Makassar trader, the *golekkan* or Madura trader, the *leteh-leteh*, and the *lambok* from Madura. No wonder the harbour was referred to as a 'veritable Charing Cross for shipping' by Charlotte Cameron, writing in 1924.

The opening of the Tanjong Pagar docks and wharves in the 1860s set the pace for the magnificent harbour which Singapore boasts now. The concentration of immigrant labour in this area led to the building of the picturesque jinriksha station in

1904 at the intersection of Tanjong Pagar Road and Neil Road and the siting of coolie depots, where coolies from China were brought to be transferred to different areas. It is interesting to note the development of this locality due to the exigencies of the times—from a predominantly agricultural area of nutmeg, gambier, and fruit gardens to a dockyard locale

3

Life in Old Singapore

We are the children of our landscape; it dictates behaviour and even thought, in the measure to which we are responsive to it.

Lawrence Durrell

IN 1834 P. J. Begbie wrote about Singapore: 'The whole town has an appearance of great bustle and activity, which inspires the spectator with an idea that he is gazing upon a settlement which is naturally rising into importance under the united influences of English capital and industry and an advantageous locality.' His words, judging from the expansion at the end of the century, were prophetic.

The people encountered on the streets reflected this diversity and were an ethnographer's dream, an amazing spectrum of race and hue (Plate 9). Distinctions were all the more noticeable because of the fashion cues taken from the communities' country of origin. The Arabs were statuesque in loose flowing robes, the Chinese workers donned loosely cut trousers and Mandarin coats, the Indians sported a variety of vivid costumes, the Malays wore their patterned sarongs, the wealthy Chinese merchants were distinguished by their silk and brocade, and the Europeans persisted in attiring themselves as they would have in chilly England, but with this modification: the men donned the topee, a pith helmet, at all times—including when they went swimming—to prevent sunstroke (Plate 10). The advertisements from the *Straits Times*, reproduced on page 34, are indicative of the variety of European goods available here in 1883.

The impression left by various travellers is that of a British town. Helen Candee (1927) wrote: 'You live there in an English hotel, with English people about you, and English motor cars driving up to the entrance below your balcony. Across the

33

NOTICE

ROBINSON & Co. beg to announce the arrival per S. S. *Glenfruin* and other lately arrived steamers, of a complete assortment of new goods, including

Gents' Black Felt Hats.

Fancy Rustic hats for Lawn Tennis.

Felt helmets. Straw hats.

Gent's Socks in striped and plain, cotton, merino and cashmere.

White Shirts, with and without Shakespeare collar.

Oxford and Regatta stirts.

Waterproof coats and caps.

Calf, Patent, Canvas and Lawn Tennis Shoes.

Towels, umbrellas, tin travelling trunks, railway rugs, undervests and a large assortment of West of England tweeds, worsted coatings, broadcloths and Bedford Cord.

Lawn Tennis Bats and Balls.

Also

Pears' Transparent Soap.

Pears' shaving sticks.

Gosnell's Cherry tooth paste.

Gosnell's Cherry tooth powder.

Rimmel's Brilliantine.

Singapore, 5th April, 1883.

NOTICE

ROBINSON & Co. are now opening a large shipment of Ladies' new dress materials:—

French Cashmeres, Alpacas, Sateens.

Zephyr and Nuns' cloth &c., in all the newest colors.

Satins, Ribbons and Velvet to match.

Fancy check Silks for Trimming.

Broché Satins in Black and colors.

Pompadour Sateens, Oatmeal cloth.

New Sash Ribbons.

Velveteens, Serges and Grenadines.

Fringes, Chenille and Silk in every shade.

Colored Silk and Metal buttons.

Lawn Tennis Pinafores, in the latest patterns of Pompadours, trimmed Lace.

A good stock of Laces, Frillings, Gloves, Mittens, &c., &c.

Six button, Black suede Kid Gloves.

Ladies' Lace Shoes in Calf and Kid.

" Button Shoes.

" Evening Shoes, fancy bows.

" Morocco Shoes, embroidered toes.

White Satin Shoes.

Children's Boots and Shoes.

Singapore, 5th April, 1883.

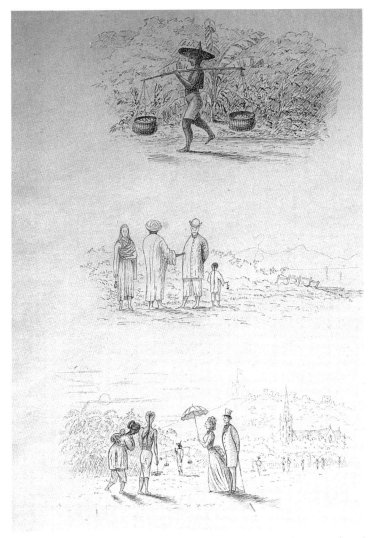

9. Three sketches by Henry N. Shore (1847–1926): 1. Coolie; 2. Arab and Chinese; 3. East and West or Comfort vs Fashion. Courtesy History Section, National Museum of Singapore.

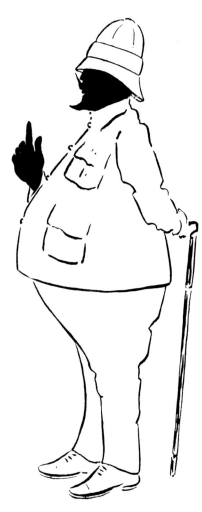

10. Caricature of a European with his topee, from *Shadows on a Malayan Screen*, by W. G. Stirling, Singapore, 1926. Courtesy Antiques of the Orient.

square is an English club, and standing within the wide stretch of trees and lawn is an English cathedral with English chimes that ring out the English hours.' However, to the perceptive eye, it was still an Eastern town.

A still extant symbol of the juxtaposition of British and ethnic precepts is the bungalow, the residential house which the British brought with them from India. This was a local village hut whose origin can be traced to 'bangla', meaning 'of Bengal', which was adapted to suit the functions of a European dwelling. In Singapore the word referred to a single-storeyed building raised about 2 feet from the ground on small pillars or timber posts, allowing for a space underneath. There was generally a large central hall for a combined sitting- and dining-room and a bedroom at each corner. The roof came down low on each side and verandas ran the length of the house. This soon became the expected mode of housing wherever the British settled.

Raffles, when he built his first residence in Singapore, incorporated the Malay elements of a wooden kampong house. As noted earlier, it was a long low building with wide verandas, set

on Government Hill to catch the breeze. However, some basic differences between the bungalow and the Malay house serve to highlight the distinctions in the nature and the life-styles of the residents themselves.

The houses of the European residents were cloistered within large compounds with well-tended gardens signifying the European love of gardens and of privacy, a desire to be distanced from the alien surroundings they were in. The elder Braddell's advice to his son Roland, quoted in the latter's book published in 1934, epitomized this attitude: 'If you want to be happy, remember that the country is just around the corner waiting to blackjack you. Don't admit that you are living in an oriental city; live as nearly as possible as you would in Europe. Read plenty, the mind needs more exercise than the body; keep yourself up to date; have your own things around you, and as much beauty as you can in your own home. Above all, never wear a sarong and baju; this is the beginning of the end.'

Considerable light and ventilation came from the cross-currents of air obtained by keeping the hall open at front and back, and in the daytime the verandas provided shade from the glare. Often the doors and windows were covered with *thatties*, or blinds, made from reed mats which were pulled down in the afternoon to keep out the noonday glare and the fierce afternoon heat. Punkas were an Anglo-Indian device designed to alleviate the heat and the humidity of the tropics. As described by Heber in the *Hobson-Jobson*, they were 'large frames of light wood covered with white cotton, and looking not unlike enormous fire boards, hung from ceilings of the principal apartments'. Young boys were employed to pull the cords which were attached to them to promote a breeze.

Soon, however, social hierarchies brought about distinctions in the bungalows. The houses of the highest colonial officials and the rich Chinese became more elaborate with classic columns, elegant ornamental balustrades, and grand porticoes or *porte-cochère*. Later, some bungalows became two-storeyed with the covered area above the porch being used as an informal sit-out. The maintenance and running of an immense household

like this called for a retinue of labour which often included an Indian butler, a Chinese amah, a Chinese cook, a lamp lighter, an Indian or Malay *kebun* (or gardener), a driver, and assistants for some of them. Most of them were usually housed in quarters away from the main house. The kitchen was also at a distance and was linked to the veranda at the back through a covered walkway. Originally, convicts provided some of the domestic service, but their role was eventually supplanted by the influx of immigrants from other lands.

The settler and the visitor alike took advantage of this life of indolence. Ross's (1911) caricature of the old-time merchant skipper setting out in Singapore with his entourage is amusing: 'One held a green-lined umbrella over his sacred head, another carried a small coil of smouldering rope in his hand, in case Captain Bangs might want to light a cigar, while yet a third was in charge of a japanned deed-box.'

Life for the Europeans was orderly and regulated in an attempt to emulate and preserve qualities which were considered worthy of their race, and their routine signified a faithful adherence to the promotion of the values which they had grown up with: punctuality, discipline, exercise, privacy, and orderliness. They had a life-style they could not divest, as is shown in Plate 11 of a lady dressed in her afternoon best, having tea on the lawn in the sweltering heat.

The resounding of the 68-pounder gun from Fort Canning heralded the important hours of the day—5 a.m., 12 noon, and 7 p.m. The clock regulated all other activities of the day, some of which necessitated the use of 'strange methods'. Having a bath, for example, involved the sloshing of cold water from a large bathing jar very much like the one Ali Baba and his entourage concealed themselves in. This so-called Shanghai jar (or Suchow tub or Siam jar), in which the water remained cool because of the evaporation through the porous clay, was often used to chill beer. There is the amusing anecdote about the European gentleman who, in his ignorance, stepped into the jar, thinking to use it as a bathtub, only to get stuck in it.

Meals tended to be ample with a predominance of curry and

1. 'A Path Across the Swamp in Changi', by Eduard von Ransonnet, 1869. Courtesy Antiques of the Orient.

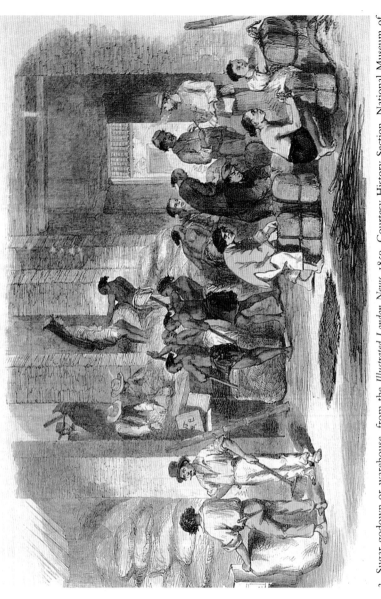

2. Sugar godown or warehouse, from the *Illustrated London News*, 1859. Courtesy History Section, National Museum of Singapore.

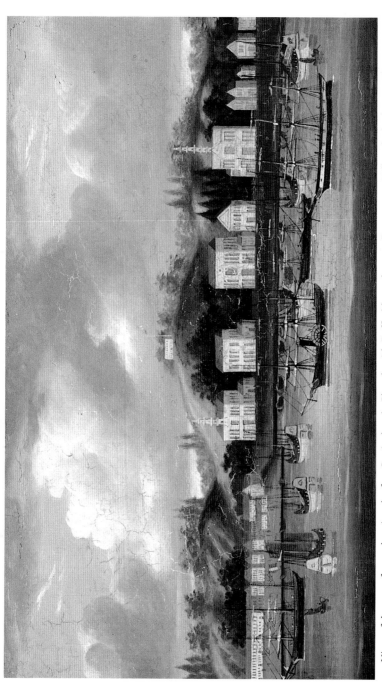

3. View of the waterfront, showing the first St. Andrew's Church with Raffles' bungalow on Government Hill in the background. China trade oil painting by an anonymous Chinese artist, c.1840. Courtesy Antiques of the Orient.

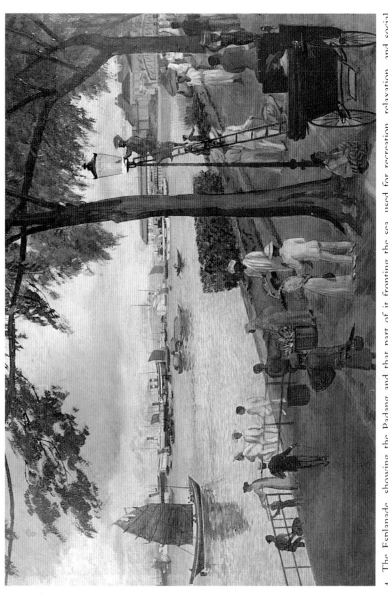

4. The Esplanade, showing the Padang and that part of it fronting the sea, used for recreation, relaxation, and social occasions, by A. L. Watson (1905–10). Courtesy History Section, National Museum of Singapore.

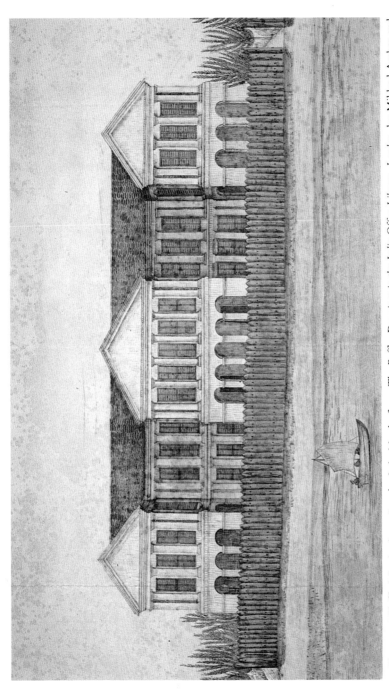

5. Singapore (Raffles) Institution, 1841, by J. A. Marsh, from *The Raffles Drawings in the India Office Library, London*, by Mildred Archer and John Bastin, Kuala Lumpur, 1978.

6. View of the Singapore River, by Percy Carpenter, 1858. The bridge in the background is J. T. Thomson's wooden footbridge built in 1844. Courtesy Antiques of the Orient with kind permission of J. Grimberg.

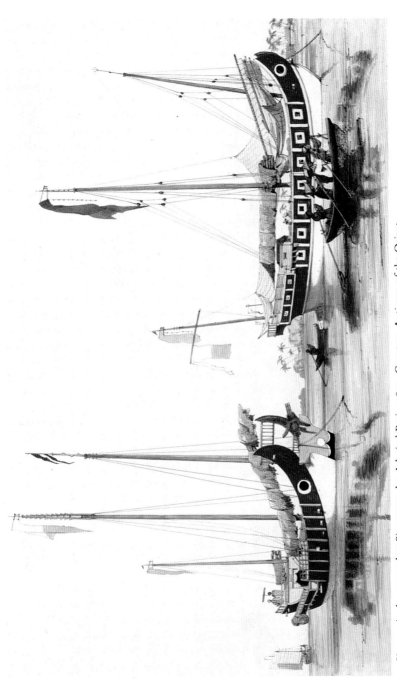

7. Siamese junks moored at Singapore, by Admiral Paris, 1841. Courtesy Antiques of the Orient.

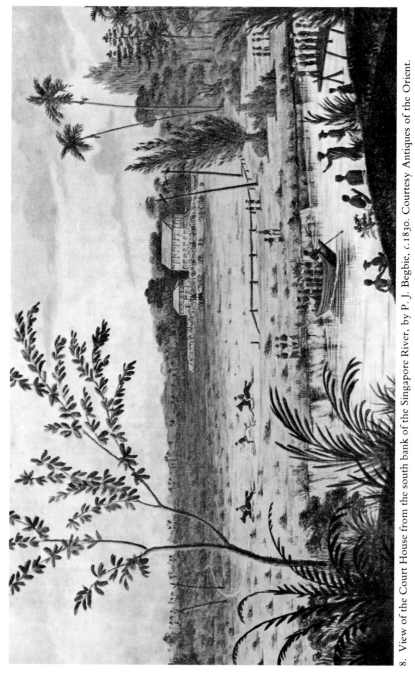

8. View of the Court House from the south bank of the Singapore River, by P. J. Begbie, c.1830. Courtesy Antiques of the Orient.

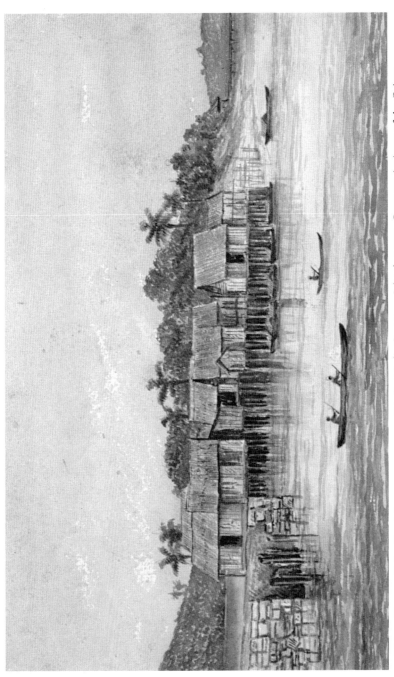

9. Malay village on Pulau Brani, by an anonymous artist, East India Company School, c.1830. Courtesy Antiques of the Orient.

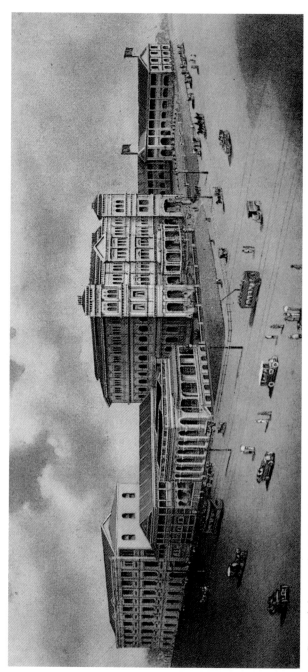

10. Postcard showing the Raffles Hotel, c.1910. Courtesy Antiques of the Orient.

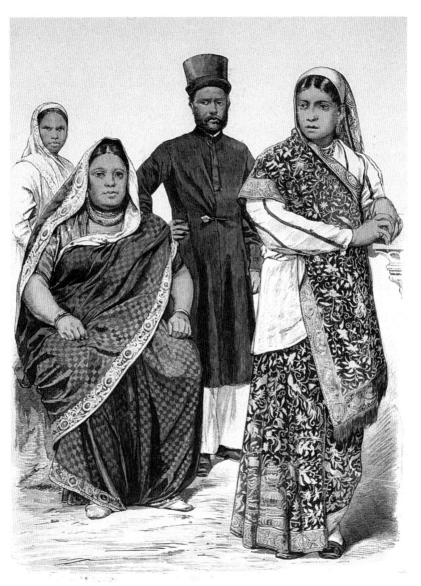

11. 'Barfi Aus of Tindien', showing an Indian merchant and his family, presumably by a German artist, date unknown. Courtesy History Section, National Museum of Singapore.

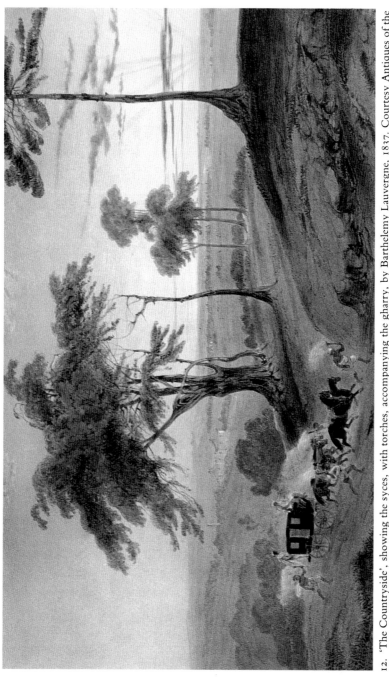

12. 'The Countryside', showing the syces, with torches, accompanying the gharry, by Barthelemy Lauvergne, 1837. Courtesy Antiques of the Orient.

13. Postcard showing the Orchard Road Railway Bridge with train, and other vehicles on the road, c.1913. Courtesy National Archives of Singapore.

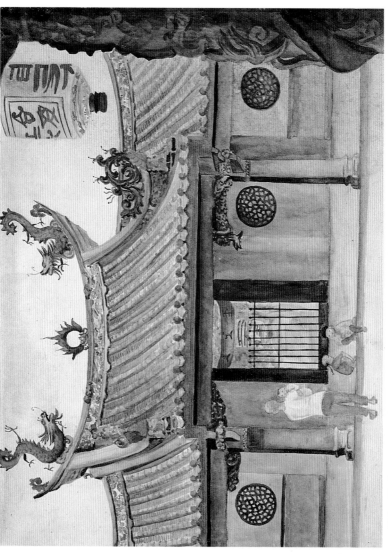

14. Thian Hock Keng Temple, by Mrs K. Codrington, 1917. Courtesy Antiques of the Orient.

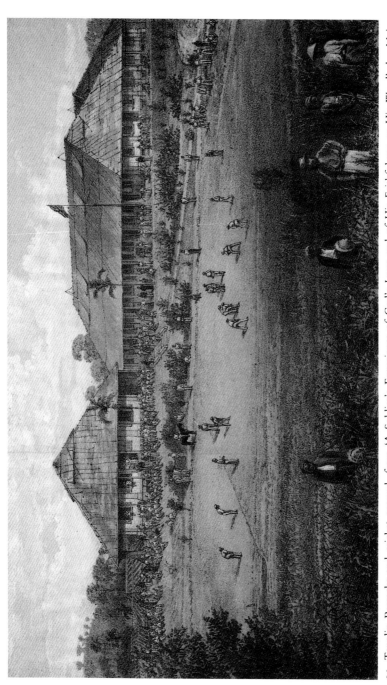

15. Tanglin Barracks and cricket ground, from 'A Soldier's Experience of God's Love and of His Faithfulness to His Word', by Major C. H. Malan, London, 1875. Courtesy Antiques of the Orient.

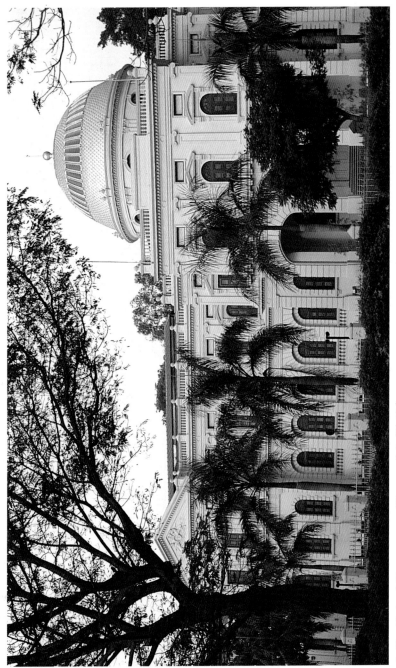

16. The National Museum, 1991. Photograph Judith Balmer.

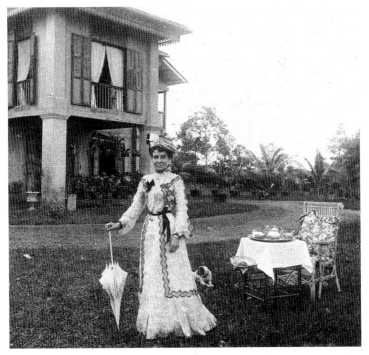

11. Lady on the lawn of her bungalow, from a postcard, c.1908. Courtesy Antiques of the Orient.

rice. Dinner was more substantial and leisurely, especially if it was a social evening. However, an easy cameraderie did exist in spite of the generally rigorous social etiquette, so if a guest was invited out to dinner, he could take along his own cook to help the hostess out. Thomson describes the contents of one such substantial repast. He says that after the soup came fish, joints of Bengal mutton, Chinese capons, Kedah fowls, Sangora ducks, Yorkshire hams, Java potatoes, and Malay ubis. This was followed by curry and rice flanked by sambals, Bombay ducks, salted turtle eggs and omelettes all washed down with pale ale. Dessert was a riot of macaroni puddings of all shapes and custard downed with champagne. Then was served a huge

round cheese. Finally, the table was cleared and a variety of tropical fruit was served.

The fruit must have amazed the foreigner. Caine (1888) talks of buying mangosteen 'with its kernel of shining pulp, milk white streaked with a little yellow', pineapples, bananas, lychees, custard apples, and the golden mango, which has been drawn as being eaten in a bathtub, probably the ultimate in decadent living! (Plate 12). Since matches had just been invented, and were still unusual, it was the custom for troughs with lit joss-sticks to be proffered for the after-dinner ritual of smoking.

The men were usually driven in carriages to their offices in the administrative or trading quarters of the town. The offices of the trading houses were generally over the godowns which fronted the quay for convenience in loading and unloading of goods. They presented a scene of astonishing activity. Above the footways of the godowns was a broad wooden veranda bounded by a balustrade and this formed an extended corridor which obviated the necessity to use the stairs to visit someone in the row. There was also a telescope kept for a *thamby* (an office boy) to look through to site the arrival of ships, especially those carrying mail. Snakes were apparently kept as pets in order to counter the destructive rat menace in these warehouses.

12. 'Singapore—a mango breakfast in July', from *A Trip around the World in 1887–8*, by W. S. Caine, London, 1888. Courtesy Antiques of the Orient.

Exercise and entertainment came in many forms and served to alleviate the loneliness of the place and the exigencies of the climate. A lot of walking and riding were done, usually in the cool of the morning. The equestrian habit inspired this humorous poem by Din in 1885:

> Ride a cock horse
> To Tanglin and back
> To see a fine gent
> Upon a grey hack,
> With arms in the air,
> And glasses on nose,
> He shall be laughed at
> Wherever he goes.

Cricket was played on the Esplanade, and a Fives Court was built, in 1836, for a game similar to squash but using the hands instead of racquets, on the site where the government buildings at the edge of the Padang now stand. Gradually clubs for recreation began proliferating. They promoted gymnastics, ladies lawn tennis, cricket, football, swimming, and billiards. Racing was introduced in 1840, with a racecourse which is now the Farrer Park Recreation ground (Colour Plate 8).

Some days were more important than others. For instance, the closing of the mail, in order to catch the steamers taking it to Europe and other countries, signalled from the Fort Canning flagstaff, brought on a flurry of activity. Isabella Bird, talking of the 'dreary, aimless life' of the ladies, says: 'The greatest sign of vitality in Singapore Europeans that I can see is the furious hurry in writing for the mail.'

Amusements those days were something to be looked forward to, to be discussed and planned at length, not an everyday happening taken as a right. Amateur theatricals and dance halls provided much of the entertainment. Hunting, a sport that carried all the hallmarks of prestige and status, was indulged in assiduously. In the hinterlands of the town there were snipe, plover, and pigeon. There were also crocodiles, pigs, deer, and

male and female jackals introduced from Bengal which multiplied beyond expectation. Thomson mentions that 'tigers of the largest size roamed in the jungle; and the destruction of life was of daily occurrence'. According to him, the capture of a tiger was an occasion for a holiday and Europeans would come to look at it.

A young man who came out to Singapore had his duties and instructions cut out for him. Life was dictated by the etiquette of a faraway land. The new entrant would hire a conveyance and drive around to certain addresses and drop his visiting card into little boxes installed for this very purpose in front of the houses. Then he would wait for the invitations to come.

The Malay house was synonymous with the nature and beliefs of the Malays. It was a reflection of their harmony with their surroundings, in which the environment was enhanced, not exploited. The Malays lived in kampongs, in communities which flowed around them and of which they were an integral part (Colour Plate 9). The houses were constructed of a timber frame, an *atap* roof of Nipah palm fronds, and flooring made from split Nibong palm, applied with a resin for repelling the termites. They were deliberately constructed on stilts: to create more ventilation by letting the air flow below and through the house, to provide additional space for storage of goods and animals, and to prevent floods and termites from affecting the house and its inhabitants. This particular feature of elevating the house, albeit using brick pillars instead of wooden posts, was later adopted in the bungalows as a sensible antidote to the hot, humid, tropical environment.

The covered porch was connected to the long veranda which was used for casual entertainment or for a siesta so essential to revitalize one's flagging energy in the tropics. The whole structure depicts a tremendous flexibility in the use of space. Variations in the form of decorative panelling and the use of glazed tiles on the steps leading to the porch distinguished the well-off from the others.

When Raffles landed in Singapore, he found the indigenous Malays and the Orang Laut clustered around the Singapore

River under the tutelage of the Temenggong of Johore, with whom they had an easy relationship, providing services as boatmen and messengers. In time, there was a certain degree of assimilation between the Malays and the Orang Laut, and Raffles, with due consideration for their aquatic predilictions, designated their dwelling areas to coastal regions, offshore islands, and Kampong Glam since, as mentioned earlier, the Glam tree was essential for their boating industry.

As the Singapore River increased in importance as the focus of trading, the Malays were relocated to Telok Blangah in 1823. Raffles' call to merchants and traders from adjoining islands was heeded by the Bugis from Makassar, the Malays from Johore and Malacca, the Javanese and Boyanese, besides other communities. Those of Malay origin settled in individual kampongs mainly along the Rochore River and in the Geylang region, which was first called Geylang Kelapa because of the profusion of coconut groves, then Geylang Serai due to the cultivation of lemon grass for citronella oil. But when this demand fell, part of the area was given over to the production of *ubi*, or tapioca, and even now there is a Jalan Ubi in this area.

The Bugis faction comprised the initial settlers who had fled from Riau in the early 1800s and the later traders. Their arrival was colourful and exciting. They came in their traditional picturesque boats with the holds full of exotic birds like cockatoos, parrots and parakeets, as well as spices and sandalwood, shells and colourful sarongs, and exchanged them for opium, antimony, hardware, and textiles. They sought refuge from the monsoon for about four to six weeks in the harbour before returning. Originally, Telok Blangah was where the Bugis stopped off, and according to Bahri Rajib (*Straits Times*, 12 February 1991), 'Blanggah means a stopping place'.

The Malays (Plate 13) had a special affinity with the soil and the water and were excellent boatmen and builders. The Regatta, which was held every year, was an occasion to excel in the water with effortless ease and grace. McKie (1942) describes the grand gesture of the winner in boat races who

13. Malay couple in their distinctive attire, c. 1900. Courtesy National Archives of Singapore.

would jump from his moving boat, swim to the judges' boat, collect his winnings in his mouth, and swim back to join the next event, all in one continuous lithe movement. Their pleasures were simple: kite-flying, top-spinning, and cock-fighting. John Cameron mentions that the abundance of fireflies led to the Malay women catching them and confining them in miniature cages to be used as shining ornaments. Wilkes says that

the Malay villages through which he drove had a 'joyous look, and the population was apparently occupied in amusing themselves during the holidays. Some were engaged at football, and many of the boys and men were playing "hobscob".'

Being excellent raconteurs and performers, the Malays naturally gravitated to the *bangsawan*, a stage performance introduced to Penang on the Malay Peninsula by visiting Indian Muslims during the 1870s, and adapted, in 1902, by an Indian Muslim for the Malays. The stories central to the *bangsawan* are from the *Sejarah Melayu* (Malay Annals) or the Hindu classics and, on occasion, even Shakespeare. Wright and Cartwright mention the Malay theatre in North Bridge road where plays ranging from Ali Baba to Romeo and Juliet were presented before crowded houses.

Because of religious similarities, the Malays mingled easily with the Indian Muslims and the Arabs, among whom may be mentioned several well-known families like the Alsagoffs, the Aljuneids, the Alkaffs, and the Talibs. Many Arabs came originally from the Hadramaut region, now part of the People's Republic of South Yemen. India was a link in this pattern of immigration because many of the Arabs had gone first to Hyderabad in the Deccan as traders and mercenaries in the employ of the Nizam, and had demonstrated their fealty by fighting against the British. According to a descendant of the Alsagoffs, his great, great, great grandfather established the Singapore branch when he came to trade in spices in 1824. There was intermarriage with Bugis royalty, a daughter of Hajjah Fatimah, from the Sultanate of Gowa in Celebes, and it is in her honour that the mosque in what was then called Java Road was built. This is a picturesque mosque which boasts a leaning spire and tower. The family owned extensive properties, including the Perseverance Estate, mostly in Geylang Serai, and several seaside villas. In the mid-1900s, Syed Omar Alsagoff, one of the scions of this family, had a house opposite Bukit Tunggal, called Omran Villa, with a large natural pond containing three man-made islands named after the Straits Settlements of Malacca, Singapore, and Penang. On each

island, measuring about 20,000 square feet, there was a guest house.

The Alkaffs, equally prominent, can trace their arrival in Singapore to 1852, when the first Alkaff came to trade in spices, scrap iron, and clothing. The family was responsible for the much talked of Alkaff Gardens, built in the 1920s, which boasted a huge lake for boating and rowing with simulated Japanese scenery and a live camel! During the Second World War, it was requisitioned by the British Army, and now it accommodates the Sennet Estate.

The Arabs were a close-knit community, and the older generation clung to many traditions from their homeland, including their dress—flowing robes and distinctive headgear (Plate 14)—and the celebration of important days with traditional food such as dates.

The Malays, the Indian Muslims, and the Arabs built many mosques including the Fatimah, Al-Abrar, Jamae, Sultan, and Masjid Abdul Gafoor, and one *kramat*, the Nagore Durgha.

The spare, elegant St. Gregory's Church or Armenian Church, situated in Hill Street, was named after the first Armenian monk who lived in the fourth century AD. From the first small chapel behind the old John Little's department store in Raffles Square, dating the first settlers to soon after the foundation of the settlement, to the present church built to Coleman's design, it has remained the focus of the life of the Armenians settled here. It is the oldest church and the most unaltered of his works. The tombstones in the tranquil compound have been brought from the Kampong Java cemetery.

According to an old-time resident, Arshak Catchatoor Galstaun, there were fewer than ten residents at the time the church was built with funds from the Chinese, Malays, Arabs, and Jews. Some Armenians came from Indonesia, but some came after an education in Calcutta, where there was a more substantial population. Their vocations were diverse. Mackie Martin, who was interviewed by the Oral History Department, claims that his grandfather was one of the first to open a pineapple factory in the latter part of the nineteenth century,

14. The Arab community of Singapore, c.1910. Courtesy of Mr Ameen Ali Talib.

and his father's uncle was credited with operating the first hand-projected cinema on a drop screen. He narrates how, in order to make the movie realistic, his grand uncle let off Chinese crackers to simulate the sounds of the war being enacted. Others ran boarding houses and hotels, such as the Oranje Hotel where Stamford House now stands. The three Sarkies brothers, starting off with a small Tiffin Room in 1886, built it up to become what it was and is, a meeting place for the rich and the famous, epitomizing a nostalgic reminder of the days of yore—the Raffles (Colour Plate 10).

The Jews, like the Armenians, came from all walks of life. Their migration was from both the Middle East and from Europe, the earliest reference being to a group of nine Jews who arrived from Baghdad in 1830. The early migrants from India and the Middle East spoke either Arabic, Hebrew, or Hindi and often wore the Arabic style of dress. Thomson describes an 'oriental Jewish merchant in Singapore called Abraham Solomon ... [who] dressed in the flowing robes of the East, and a large turban covered his head'.

The first synagogue, the Maghain Aboth, was completed and consecrated in April 1887 in the area near Boat Quay. This was sold after thirty years and Manasseh Meyer, the Grand Old Man of the Jews, built another synagogue on the grounds of his beautiful house on Oxley Rise in 1905, calling it the Chased-El (Plate 15).

The Eurasians trace their origins back to the time of Raffles or a little later. Like the other immigrants, they came from all corners of the world: India, Ceylon, Malacca, Portugal, and Holland. They were active in commerce, law, medical service, the government, and trade. Their life-styles were more Western, their ladies more liberated in terms of movement. Singaporean Jocelyn de Souza traces her descent to her Portuguese ancestor who came to Penang in 1711, while Evelyn Norris traces hers to William Norris who came with Raffles.

According to the Moores, the 'sinews of commerce and colony-building' were provided mainly by the hard-working opportunity-seeking Chinese and, to a lesser extent, the Indians.

15. Chased-El Synagogue, 1991. Photograph Judith Balmer.

When Raffles landed, there were but a handful of Chinese on the pepper and gambier plantations inland, a profession they would continue to practise. The Chinese fled their homeland for a variety of reasons: the dire conditions at home, such as excessively high taxes, the paucity of cultivable land, natural calamities, and the grim prospect of death by starvation. Many were lured by tales of profit from kith and kin who had already migrated to Singapore, and, in many cases, they were kidnapped by exploiting agents. They suffered unspeakable conditions on the journey out, sometimes reaching Singapore more dead than alive. As the *Singapore Free Press* of 22 April 1847 reported, 'Some little time ago a large Chinese Junk arrived here which had left China with nearly 400 persons on board, of whom 90 died on the voyage, from starvation.'

They came in droves, as traders, artisans, coolies, and craftsmen, and if they could not find a suitable vocation, with the assiduousness so deservedly attributed to them, they put their minds to whatever was available—tailoring, barbering, planting, domestic work, mining, or peddling. Foran (1935) describes the Chinese hawker or 'box-wallah' as 'generally a bland and

cheerful scoundrel, who speaks a number of Eastern languages fluently and passably good English. He is a first-class salesman always—courteous, patient, seldom accepts a rebuff seriously, and can blarney with the best.'

The Chinese brought their culture and creeds with them and lived by their precepts and ethics. The group, rather than the individual, has always been the focus of the Chinese way of life. The temples that they built, therefore, served not only to acknowledge the help of the gods in bringing them safely across the perilous seas, but also as centres for the various clan associations or dialect groups, which met the immigrants' emotional, financial, social, and physical needs.

They settled mainly in the Telok Ayer area which fronted the sea at that point of time—in China Street, Circular Road, Boat Quay, South Bridge Road, Upper Cross Road, and Bukit Pasoh. All were not overnight success stories, but perseverance and a strong community feeling resulted in hard work paying off, and by the end of the century they had become a prosperous community contributing to the success of Singapore.

By and large, the shophouse has come to be associated with the Chinese. It could have arisen out of Raffles' stipulations about the building and its continuous veranda, and the fact that the plots of land were long and narrow. Unlike the Europeans, who chose to live in areas away from the workplace, the industrious Chinese could live upstairs, thus facilitating not only the supervision of work and employment of other family members, but also ensuring the safety of the premises. By the late 1800s, many of the more affluent, however, had moved to so-called European areas like Tanglin, where they lived in bungalows, with some even eschewing the traditional queue, a Manchu heritage, and adopting the British mode of dress. However, this was mainly superficial, for traditional values still remained essentially Chinese.

The Chinese, who were generally a very hard-working people, found relaxation and entertainment in the form of celebrations of annual festivals and rites of passage. Their festivals were colourful, spectacular, and noisy. Chinese New

Year was specially picturesque with the markets teeming with life and goods, including a variety of eatables peculiar to the festival imported from China. The predominance of red, and the explosive firecrackers which hung from the godowns of the Chinese merchants fronting the Singapore River added to the atmosphere. For the Mooncake festival in mid-Autumn, the lanterns took pride of place, setting the nights ablaze with their colour and design.

Not every traveller, however, was ecstatic about visits to Chinatown or a Malay village. Charlotte Cameron comments on the congestion and the open-air restaurants and the food: 'Their dried fish looks as if it must have been preserved since the days of the Ark. There are tentacles of octopus, *bêche-de-mer*, and little stuffed meat balls strung on sticks, which must form a happy hunting-ground for insects.'

Leisure time was spent in gambling. As Wilkes said, 'It was extraordinary to see all engaged in such an exciting vice; and to watch the different individuals was amusing. Gaming was going on in every shop, and frequently in each particular corner, under the colonnades, in the bazaars, and at the corner of almost every street a variety of games were playing.'

They were also fond of *wayang*, or Chinese operas, which were performed on raised makeshift stages at street corners, or near temples as expressions of thanksgiving (Plate 16). The earliest record seems to be in the mid-1800s and the predominance of the theatre in the area near South Bridge Road led to the name of Theatre Street.

Mention of the Chinese must include the grand old *towkay* who symbolized success and fame, Hoo Ah Kay or Whampoa (Plate 17). His life-style was extravagant: he had an enormous house with an orangery, a Chinese garden, a rockery, an artificial pond, an aviary with a cassowary, and a pond with an exquisite lotus plant sent by the King of Siam. Edward H. Cree, a surgeon of the Royal Navy, tells of the legendary hospitality of this gentleman who was equally at home in both cultures, and who could recite long passages from both Shakespeare and Byron and 'put the proper emphasis on the words'

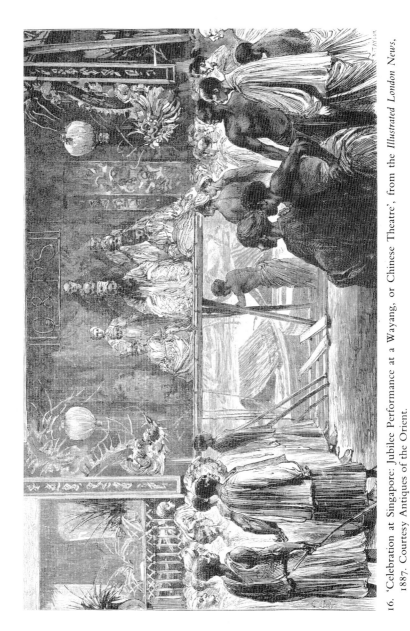

16. 'Celebration at Singapore: Jubilee Performance at a Wayang, or Chinese Theatre', from the *Illustrated London News*, 1887. Courtesy Antiques of the Orient.

17. Whampoa sitting in one of the gateways of his house, from *The Graphic*, 1880. Courtesy Antiques of the Orient.

(Levien, 1981). There were many others who lent their efforts to philanthropic works, such as Tan Tock Seng, Hong Lim, Tan Yeok Nee, and Seah Eu Chin.

The Babas (Plate 18) had a unique culture and heritage. 'The Babas ... are Chinese of mainly Hokkien origin descended from the intermarriage of early Malacca Chinese with local women of various races with their Chinese blood re-inforced by marriage with Chinese immigrants who came in the latter half of the 19th century' (Cheo Kim Ban, 1983). They evolved a special life-style. Their form of worship was often Chinese whereas their style of dress and entertainment, such as the dance-forms of *joget* and *ronggeng*, was adapted from the Malay. They took to Western education easily and were in the forefront in that sphere.

The Indians migrated in waves to Singapore. They came first with Raffles as sepoys in a regiment of the Bengal Native Infantry and as camp followers, then later as convicts after the Anglo–Dutch Treaty of 1824 when Bencoolen was exchanged for Malacca and the Indian convicts relocated to Singapore. One of the first Indians to carve a successful niche here was Naraina Pillai, who came with Raffles on one of his voyages and set up the first brick kiln. Later waves came as indentured labourers, to work on the plantations and the mines in Malaya, and as cattle importers in the late nineteenth century to the Serangoon Road area where there was an abundance of water and grass supplies.

Before the early twentieth century they were merely birds of passage. 'The Klings are but transient visitors to Singapore. They come ... from the neighbourhood of Madras, remain for two or three years, obtain a little money and return', wrote Wilkes. However, this soon changed. Towards the end of the nineteenth century, increasing numbers of individual commercial migrants came as traders, shop assistants, clerks, and educationists.

They were a colourful race, bringing literally a touch of spice with them and adhering to the customs from the home they had left behind (Colour Plate 11). Their stature and appearance

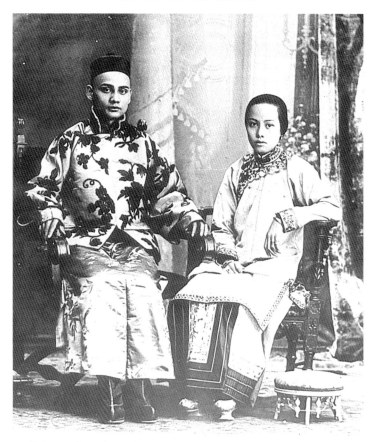

18. Baba couple, early 1900s. Courtesy National Archives of Singapore.

attracted considerable comment from Europeans, including Emily Innes who, in 1885, wrote: '... a well dressed and handsome Kling woman, even though she might be only a coolie's or washerman's wife, was a far more beautiful sight in my eyes than the most fashionably dressed European lady of Singapore, whoever she might be, with her whalebone and steel, her kilted plaitings and angular frills, her pinched-in waist and distended skirts.'

There was tremendous ethnic (Gujeratis, Sikhs, Malayalees, Tamils, Sindhis) and religious diversity which manifested itself in the mosques and temples which soon sprang up.

The Indian influence seeped into the local cuisine, in the inclusion of *roti paratha* (which in India are two different types of flat breads, whereas in Singapore it denotes just one), *nasi biriyani*, *putu mayam*, and so on.

For relaxation, Wilkes says, 'The Hindoos of the Gentoo faith, also, have various amusements, among which are vertical revolving swings, with four boxes or seats in which the occupants maintain a horizontal position. These are seen among us; but it is in the East that the fashion has originated. The machine was awkwardly made, and with its creaking added not a little to the general din.' Like other Asians, they also liked the theatre, indulging in their passion for colour and drama in stories about battles and royalty.

Religious festivals included Deepavali, the festival of lights, and the Chettiar Thaipusam, both noisily celebrated with firecrackers till their use was prohibited for safety reasons.

This, then, was the multihued potpourri that was Singapore. Though originally the different ethnic groups were designated separate areas of settlement, there was flexibility of movement and there was sufficient demographic mobility to ensure interesting cultural symbiosis such as the worshipping of the idol in the Sri Mariamman Temple by Chinese and Buddhists as a manifestation of the Goddess of Mercy, Kwan-Yin.

4
Transport in Old Singapore

> Human creatures have a marvellous power of adapting
> themselves to necessity.
>
> George Gissing

ANIMALS have from very early times served as a means of trans-
port, and so it was in old Singapore. The ubiquitous buffalo
and the graceful horse have both contributed to the vivid
impressions of Singapore left behind by various travellers. The
earliest mention of bullocks as draught animals occurs in *The
Hikayat Abdullah*, where Munshi Abdullah describes the training
of the various troops during Raffles' visit to Malacca in the
early decades of the nineteenth century: 'The very large guns
were pulled by bullocks. I was astonished to see that when
people fired guns as large as these near the animals' ears they
did not take fright or move from their places. When an officer
shouted an order to the soldiers to move at the double the
bullocks also broke into a run. When he said "Halt" the
bullocks also halted, and when the soldiers changed direction
the bullocks did likewise. It was surprising to see them behaving
like human beings.'

Their manifold uses illustrate both their sagacity and strength.
We can imagine these large black animals imported from
Malacca, India, and even Bali, with their lumbering gait and
supercilious air equally at ease pulling large loads on dusty
roads or building sites. They were used for transportation of
goods over distances (from wharves to town and vice versa), as
conservancy vehicles for carrying refuse, and for repairing
roads, carrying ballast and construction materials, delivering
mail, removal of debris from the scene of a fire, and road
rolling. Edwin A. Brown (1935), in his reminiscences, talks of
seeing an abandoned road roller on a road only to find out that

a tiger had killed the driver and carried off the bullock drawing the roller!

The name given to Chinatown in the early 1800s was Kereta Ayer or, in Chinese, *niu che shui* (meaning ox-cart water), no doubt derived from the distribution of water in bullock carts both for household use and for washing the streets (Plate 19). The significant role played by the animals is evident in names like Buffalo Road, or Kandang Kerbau Road, in the Serangoon Road area. But the animals were not without their critics. Earl voiced his irritation at these carts, covered with dust and dirt, with the 'harsh and discordant jargon' of the driver striving to make himself heard above the creaking of the wheels.

However, the bullock continued on its plodding way for many years, and put in an appearance even during the riksha strike of 1897 when the *Singapore Free Press* reported on 9 January that Europeans going to the Cricket Club in bullock carts were followed by a procession of laughing spectators. Even as late as 1930, the bullock cart was used on Pulau Bukom to carry the oil tanks.

19. Cart for washing streets, late 1800s. Courtesy National Archives of Singapore.

The horse and carriage, a more elegant and dignified mode of transport, was attributed to the British (Plate 20). It managed to survive despite the head-on march of the more plebian but convenient and cheaper riksha, but got gradually phased out by the early 1920s. It was called by various names depending on its size and elegance: *palki* (from the Sanskrit *palyanka*, meaning a bed, but with wheels), hackney, gharry, gig, buggy, phaeton, landau, and barouche. Yvan, a visitor, observed in 1855: 'But in this part of the world, the word palanquin is applied to a kind of long chest, placed on four wheels: this car, which will only hold two persons facing each other, is supplied with Venetian blinds, freely admitting the air, and covered with a tissue of very light texture.'

The horses, like the bullocks, were imported, but from Australia and India. There were also references to Burmese, Acehnese, Javanese, and Sumatran ponies. A well-known dealer of horse flesh was Daddy Abrams who had a Horse Repository where one could rent a carriage for $15 a day or $10 a drive. If tastes ran to a one-horse carriage it was cheaper, $10 a day or $5 a drive.

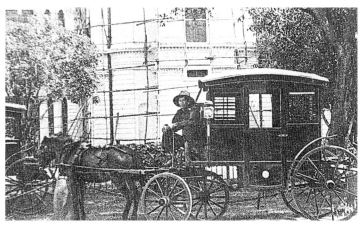

20. Hackney carriage, from a postcard, *c.*1900. Courtesy Antiques of the Orient.

FOR SALE

THE race horse "PROPHET," arrived yesterday from Western Australia. He is a brown gelding, standing nearly 16 hands, winner of the Maiden Plate, Perth, and a number of other races, and ran second to Lowlander for the Queen's Plate at Perth, beating Hero, Fireworks, Rosebury and others, all first class horses from Melbourne. Apply to

H. ABRAMS,
Horse Repository, Brass Bassa Road.
Singapore, 9th April, 1883. (to 9th May.)

Dr Oxley advised in the 1840s that 'persons intending to make this their place of residence for some months had better bring with them a Light Pony Phaeton if they wish to be comfortable: good Ponies are generally procurable from 50 to $100 each.'

These carriages were an integral part of the social scene of Singapore for various reasons. The European womenfolk and children used them to drive around on the Esplanade on certain evenings, high-born Chinese maidens proclaimed their eligibility by riding in them on specific days, and Malay and Indian women, mindful of their privacy, used them in town, preventing exposure to the outside world by pulling up the shutters in the side doors. Besides carrying the wealthy locals and the 'Tuan Besars' (the big bosses) to the office, one of the earliest Fire Brigades was also horse-drawn. Ross describes the carriage of a wealthy Parsee merchant as 'a gorgeous affair—a big barouche hung in Cee springs lined with white silk, and drawn by a pair of big Calcutta horses. The syces' liveries were a blaze of colour.'

Most of these carriages were accompanied by a Malay or an Indian groom called a syce, a word originating from the Syriac *saisi*, meaning 'to coax', which found its way into English through Arabic and Hindi. It was the disagreeable task of these

syces to run at the pony's head, guiding it with a flaming torch at night (Colour Plate 12).

Charles Burton Buckley (1902), a long-time resident of Singapore, in his book which is based on extracts from newspapers, mentions the ingenious evasion of tax by the Chinese on carts drawn by cattle by devising a three-man cart, with one man guiding it with a pole while the others pushed at each hind corner. This tax was imposed for the first time in 1841 in the hope that the money would be used for the repair and maintenance of the deplorable roads which drew complaints in the newspapers. The motley assortment of vehicles, the absence of convenient parking spots, the red laterite soil which kicked up a dust haze, and the dim lighting (oil lamps were replaced by gas only in 1906), all convened to create chaos and confusion.

And then in the 1880s occurred one of those events, which, seen in retrospect, had a cataclysmic impact on the domestic and economic front of Singapore: the import of the riksha, first from Shanghai and then from Japan, where it was invented in 1869. Besides serving its ostensible purpose of providing inexpensive transportation for people from all walks of life, it was also the conduit for employment for the alarmingly burgeoning population. The *sinkeh*—the term used to define newcomers to Singapore—were arriving in throngs, with little or no experience in urban trades, and pulling rikshas provided both gainful employment and a means of establishing a foothold in the new land.

Their uses were beyond enumeration: conveying the men to offices, clinics, warehouses, wharves, and brothels, the women to shops and for visits, the children to and from school, hauling goods such as poultry, pigs, fruit and vegetables, and bales of cloth, and according to Warren (1986), they even substituted as a makeshift ambulance service in that smallpox patients were hauled in two rikshas kept specifically for that purpose at the depot.

The description evoked by the name 'jinriksha' was apt. It was a cart with two large wheels pulled by a man running in

front between two shafts. The wheels originally had steel rims which created a din on the roads made of red laterite or ironstone gravel, for only the main roads were asphalted, but the steel rims later gave way to rubber tyres (Plate 21). The jinriksha had as protection—some would say insufficient—against the inclemencies of the weather, a hood which could be raised or lowered and an apron in front to be pulled across the chest and buttoned in case of the unpredictable torrential tropical downpours assailing Singapore.

There was, in fact, a continual effort to upgrade the condition of the rikshas, including, in 1897, a campaign to change the apron through letters of complaint to the newspapers. The *Singapore Free Press* of 12 January 1897 reported: 'Those who have had to use rikshas during rainy weather must often have seen how the black dye of the lining of the soaked aprons of the

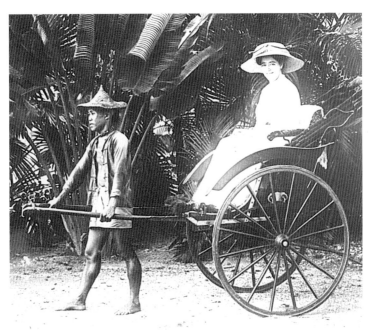

21. Lady in a jinriksha, *c.*1900. Courtesy National Archives of Singapore.

rotten material comes off on to the clothing of the unlucky hirers.' Riksha rates were usually fixed but some resourceful pullers installed accessories to improve comfort or appearance which, of course, necessitated a rise in fares. In the late 1800s, just after the riksha was introduced, many of the pullers used by the wealthy had a runner behind them, probably a hangover from the days of the gharry and the syce. There were single seaters wherein one could ride in solitary splendour, two-seaters for company or romance, and large ones to accommodate whole families. And in keeping with the laws of demand and supply, during monsoon time the fares escalated considerably.

The social, economic, and cultural impact of the migration of the riksha pullers into Singapore was tremendous. Singapore offered the promise of a better life for many of them who were fleeing arduous conditions in China. Prepared to work hard despite initial rigorous conditions, by the early 1900s they had settled down to stability. The jinriksha station built in Tanjong Pagar in 1903 is a reminder of the persistence of these people in carving out a niche for themselves.

The rikshas continued to be a powerful, though bizarre, force among the variegated means of transport, until the Japanese Occupation, when they were replaced by the trishaw. They were able to hold up their heads even through the short-lived project of the steam trams which were introduced in 1867, but which were sold to the Tanjong Pagar Dock Company within six years to be used mainly as cargo trains. Much to their chagrin, and in spite of their well-meant objectives, the advocates of the tramways found that they could not compete with the more flexible rikshas which offered literally door-to-door service at comparatively throw-away prices. The situation did not undergo any appreciable transformation even after the Singapore Electric Tramways Company was set up with six lines running through town (Plate 22). Passengers not situated at the direct ends of the lines still had to resort to rikshas to carry them to boarding stations and homes. Moreover, there were complaints of mishaps, interference with existing traffic,

22. The new electric tramcar line at Singapore, from *The Graphic*, 1892. Courtesy Antiques of the Orient.

overcrowding of cars, and deafening noise as they clattered their way through town. However, the development of some suburbs, such as Geylang, can be indirectly linked to the introduction of tramways since it was one of the destinations and the land there was relatively cheap.

In 1903 train transport was ushered in with the construction of the Singapore Railway after a prolonged delay due to decline in trade. Although a railway had been discussed as early as 1869 by a private company and the government continued to support the project, construction began only in 1900 after a government grant of $1,000,000. In 1918 it was sold to the Government of the Federated Malay States and from then on it was known as the FMS Railway.

The railway line from Bukit Timah to Tank Road Station was completed in 1903 and a few years later the line from Tank Road to Pasir Panjang was in operation. A passenger could cross from Johore Bahru by ferry to Woodlands Station, and a 1924 Municipality map shows that from here it ran parallel to Bukit Timah Road. The train went along Cavenagh Road, then crossed Orchard Road by a bridge (which was an event because it brought all traffic to a halt as it was considered inauspicious to pass under a bridge when a train was crossing, according to Van Cuylenburg, writing in 1982). It then crossed Tank Road to get to the minuscule station there. Next it puffed its way across River Valley Road, the Singapore River, Havelock Road, New Bridge Road, South Bridge Road and got close to Keppel Road. Then it traversed parallel to Keppel Road for a while, crossed Keppel, continued parallel to it and Telok Blangah before ending in Pasir Panjang (Colour Plate 13).

Motor cars chugged their way into Singapore with Buckley who imported the first car into the city in 1896. Soon motorized vehicles transformed the face of Singapore. The Singapore Fire Brigade made the momentous transition from a horse to a motor in 1907 and the first motorized ambulance appeared in 1913. The transition was not without its amusing teething problems though, and Warren writes: 'The vehicle suffered a

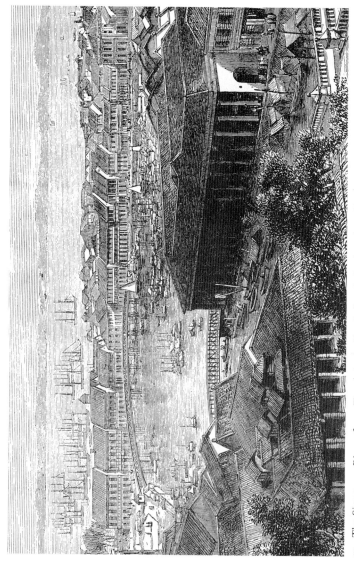

23. The Singapore River, from *Travels in the East Indian Archipelago*, by Albert S. Bickmore, London, 1868.

shortage of spare parts and on occasion those being taken to hospital had to push.'

With the advent of peace and stability in the 1920s, trolley, motor, and Mosquito buses overran the streets, the latter (deriving their names from the insect) able to dodge in and out of traffic to get to their destination in the shortest time possible regardless of the nerves or tranquillity of the passengers.

And so the progress of Singapore from a quiet peaceful trading post with its many layers of prosperity into the bustling emporium it is today can be measured by the transition of its roads from a kaleidoscope of movement as embodied in its quaint animal-drawn vehicles to the sophisticated speedy transport of the modern era like the Mass Rapid Transport, or MRT as it is commonly called.

A striking parallel can be drawn to the river transport also. The Singapore River was the hub of trade for the colonial city where the miscellaneous migrant communities lived and were involved in their activities. Unwritten rules laid down the areas designated for specific clans and communities who plied to and from the giant warehouses which stored the wealth of various countries along the river. As John Cameron so vividly wrote: 'The River is alive with boats of all sorts. Chinamen with their shoe-boats, Malays with their sampans, or fast boats, and Klings with their tongkangs . . . and so numerous are they that they generally lie three or four abreast along the entire western bank of the river, from its mouth to Elgin Bridge above' (Plate 23).

It is interesting to note that a remnant of a small community of Indians connected with boat making, called 'kaling baicki', who came in 1873, still live in Pasir Panjang. Though their numbers have sadly dwindled to eighteen, these 'carpenters of the sea' still guard their trade zealously.

Now that the Singapore River has been cleaned up, its pristine waters can but evoke memories of a colourful scene when trade was brisk and picturesque.

5

Past Mementoes and Present Survivals

> The historical sense involves a perception, not only of the
> pastness of the past, but of its presence. ·
>
> T. S. Eliot

A historical sense of time and place, which strikes the observer
in modern Singapore in spite of the slick glitz of glass and
chrome buildings and multi-storeyed bird-cage apartment
blocks, is partly due to the existence of some old buildings and
pockets of the town which retain an old world charm, façades
from the past which peer out from renovated interiors. Though,
regrettably, many of the historic constructions and houses have
come under the onslaught of the bulldozer in the name of
progress, the recognition of the necessity for the preservation
of the heritage has prevented the total extirpation of ancient
edifices and has brought about a rush of restoration, such as
the shophouses in Tanjong Pagar, and the old Thong Chai
Building, now an Arts and Crafts Centre. Once these buildings
have acquired the patina of time, they will evoke the work and
dreams of the men who shaped Singapore long ago.

Singapore has always had a visual impact on the foreigner.
Alfred Russel Wallace, the famous naturalist, commented
in 1869 that 'the town comprises handsome buildings and
churches, Mohametan mosques, Hindoo temples, Chinese joss-
houses, good European houses, massive warehouses, queer old
Kling and China bazaars and long suburbs of Chinese and
Malay cottages'.

The various migrant communities, striving to establish a
focal point of identity for themselves, constructed religious
centres. Gratitude to the powers-that-be take predominance
after a hazardous journey, and it was in this spirit that the first
Chinese joss-house to the Goddess of the Sea, Ma-Zu-Po, on

Telok Ayer, which then fronted the waves, was established in 1821–2. Reputed to be the oldest Hokkien Buddhist centre for worship, Thian Hock Keng Temple grew with subsequent renovations and help from skilled artisans from China to become the handsome edifice it is today, with its carved granite dragons (Colour Plate 14). The other well-known Chinese temple, a gazetted monument, is Tan Si Chong Su on Magazine Road, erected in 1876 by two scions of the Tan family. It is a Hokkien ancestral temple replete with courtyards and elaborate roof decorations.

The various mosques, scattered all over Singapore, depict Indian elements, Malay traits of fretted timberwork, Chinese grill work, and Turkish and Moorish resonances. The stately and impressive Sultan Mosque is perhaps the most famous, with its unusual attribute of having bottles as dome bases. The first Sultan Mosque was built on this site in 1824, and the new one replaced it in 1924–8 (Plate 24).

In comparison to the bulbous domes and the slender minarets of the mosques and the elaborately carved and tiled roofs of the Chinese temples stands the vividly encrusted 10.5-metre *gopuram* of the Hindu temple, the Sri Mariamman, dedicated to the goddess who is empowered to cure deadly diseases. The original wood and *atap* structure is credited to Naraina Pillai and the unstinted help of Indian convicts. The name Pagoda Street, on which it stands, no doubt refers to the shape of the *gopuram*.

The Cathedral of the Good Shepherd on Queen Street and St. George's Church on Minden Road both deserve mention as gazetted monuments. The Cathedral, whose foundation stone was laid in 1843, is an oasis of tranquillity in an area swarming with vehicles. St. George's has a very interesting history. It is on part of the nutmeg plantation purchased from William A. Willan in 1860 for the building of the Tanglin Barracks. It was considered prudent to move the troops who were initially accommodated at Fort Canning near the water and city for various reasons. The garrison church was originally built here although its location is uncertain. However, the background of

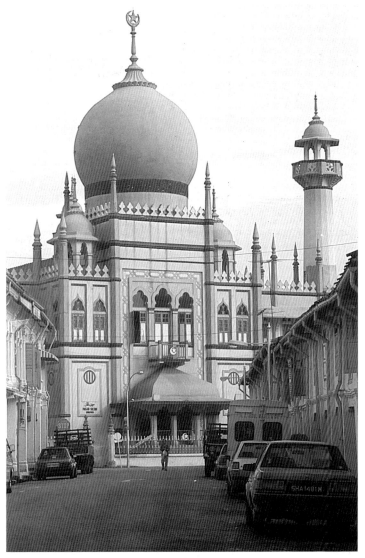

24. Sultan Mosque, 1991. Photograph Judith Balmer.

the church includes the term of a controversial yet zealous Christian man, Major C. H. Malan, who, in order to keep the men from relapsing into an alcoholic daze most of the time, thought of clearing and levelling the area to transform it into grounds for cricket and other sports. He used, he says, the roller drawn by bullocks for the parade ground, and 'a company at a time rolled it along to the fife and the drum' (Colour Plate 15) (Hattendorf, 1984).

Buildings are the emblems of power and influence of the authorities and among the edifices of colonial sway are the Government House, or the Istana, and the National Museum (Colour Plate 16). The former was constructed in 1869 on part of the nutmeg plantation of Charles Prinsep. It is a palatial building with Doric and Ionic features, strategically and pleasantly located on a grassy knoll so that it emerges half hidden from among the trees. The surrounding park is verdant. Wright and Cartwright describe it as 'a long building of noble proportions, in the Renaissance style of architecture, with a square tower in the centre ... and the whole gives the impression of solidity and comfort rather than of luxury'.

The National Museum, another landmark, stands white and glistening in the sunlight with its classic dome visible from a distance. Its recent renovation signalled the launch of the conception of the new cultural and artistic enclave of the city, which will include the Art Museum, a South-East Asian Ethnology Museum, and a History of Singapore Museum to be accommodated in various vestiges of the past such as St. Joseph's Institute and the Tao Nan School on Armenian Street, the latter designed by Major McNair and opened in 1887.

Among the hotels testifying to Singapore's colonial past are, of course, the Raffles and the Goodwood Park. The Raffles, with its Traveller's Palms and its aura of the grandeur of the Raj, was the most frequently mentioned for its ambience. Charlotte Cameron wrote that 'It has an open ballroom facing the sea, and is profusely decorated with gigantic palms. The

entire hotel is surrounded by palms and trees, and here, twice a week, are held dinner-dances and dance-teas.'

The Goodwood, with its castle-like façade, had its beginnings as the Teutonia Club in 1900, whose purpose at the time was to entertain the members of the German community with musical evenings. The three Manasseh brothers transformed it into Goodwood Hall and ran it like a gracious English manor house, with tennis on the lawn, tea served on the verandas, musical evenings, and elegant soireés. In 1929 it became the Goodwood Park Hotel and foresaw a dramatic history as the residence for senior Japanese officers in 1945 and later as the locale of the historic Japanese War Criminal trials.

The Raffles' statue, the Tan Kim Seng Fountain, and the Dalhousie Memorial all attest to the reputations of famous men. The Tan Kim Seng Fountain, an imposing three-tier iron structure in Connaught Drive, is a fitting memorial to the man who sought to alleviate the water problem in Singapore by donating, in 1857, the then munificent sum of $13,000 for a more effective water supply system. However, there was considerable delay in implementing his objective and in 1882 the authorities immortalized his philanthropy by building a fountain near Collyer Quay. In 1905 it was moved to Battery Road and twenty years later found its present niche (Plate 25).

The Dalhousie Memorial, a tall obelisk designed by John Turnbull Thomson, then Government Surveyor, in 1850, stands in Empress Place. It commemorates the visit of Lord Dalhousie, the Governor-General of India at the time. Like both the statue and the fountain, it has seen several locations before its present site. Empress Place itself, a wide pedestrian space overlooking the glimmering waters of the Singapore River, links—via the Cavenagh Bridge—the various government structures and provides a sense of history.

Among the clubs established in the 1800s which still exist, albeit much renovated and altered, are the Tanglin Club and the Cricket Club. The Tanglin Club was established in the 1860s to cater to the social and recreational needs of the Britishers living in the Claymore and Tanglin areas. It possessed

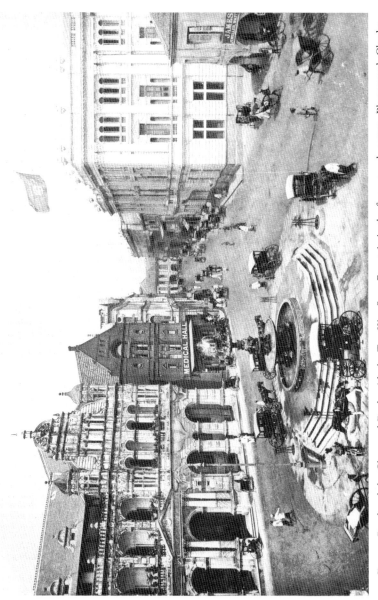

25. Battery Road and the Chartered Bank with the Tan Kim Seng Fountain in the foreground, c. 1900. Photograph Charles J. Kleingrothe.

reading, smoking, and billiard rooms, and a ballroom. While extensive renovations have been made to accommodate the increasing number of members, it still retains an essentially British interior and ambience.

The idea of forming the Cricket Club was conceived in 1852 for the express purpose of encouraging that quintessentially English sport, cricket, which was usually played on the Padang. At the beginning there was no proper clubhouse, only a temporary hut erected to provide shelter for the players and their equipment. On other days the members had to store their equipment in the Masonic Lodge across the road on Coleman Street and order their drinks from the Hotel de l'Europe, also across the street. As both membership and enthusiasm for the sport increased, the need for a more permanent structure became evident, and in 1884 the third pavilion was erected on its present site at one end of the Padang. Though it has been much enlarged, it still contains the original Victorian wrought iron work and iron pillars.

In the urban atmosphere of Singapore there still remains a place where the visitor and the resident can walk and feast his eyes on nature—the Botanical Gardens. The brainchild of Raffles, the Gardens were shifted from the slopes of Fort Canning to the Tanglin area in 1819. Since then, they have developed into a sprawling 47-hectare park with undulating lawns dotted with majestic trees, imposing rockeries, vivid rose and orchid enclosures, and serene lakes in which swans glide regally by, deigning frequently to gobble crumbs thrown by delighted children. The Gardens contain about 2,000 perennials and many exotic hybrids. One of their claims to fame is the Para rubber tree, planted by the first Director of the Gardens, 'Mad Rubber Ridley', so-called because of his strange habit of carrying rubber seeds in his pockets to distribute to planters in order to encourage them to grow rubber.

In an attempt to balance the high-density environment of Singapore, its present planners have created several other parks, such as the Chinese and the Japanese Gardens, and green spaces as buffers in high-rise areas, in the hope that future

Singaporeans will be inspired to enjoy and to appreciate them as much as present Singaporeans are revelling in the beauty of the Botanical Gardens established more than a hundred years ago.

Synonymous with this concerted effort to implement a historical consciousness has risen the need to revitalize vanishing cultural traditions. It is encouraging to see, for example, an interested audience at the Chinese operas performed at the Victoria Theatre, though indeed they are far removed from the stage shows of earlier years performed on a makeshift stage with spectators bringing their own seating arrangements and their own hand fans. Now, sophisticated stage effects have replaced the sometimes amusing improvisations, but the themes remain the same: passion, drama, war. There is help for the non-Chinese in the form of subtitles flashing on the white screen to the right of the stage, though it is slightly disconcerting to hear ten minutes of plaintive heartbreaking singing being explained away in one terse sentence: 'She says she will not marry him!'

The Malay *bangsawan*, likewise, is enjoying a comeback, as are some traditional forms of singing, such as the *dikir barat*, the traditional folk singing from Kelantan, in which teams compete against each other. The Indians also have cultural centres promoting dance and music, often with artistes from India, for with this growing awareness of history has arisen a parallel consciousness of ethnic traditions.

The resurgence of interest in trades and crafts has resulted in renovation of places like the Tanjong Pagar shophouses where traditional techniques and trades such as clog-making and kite-making are being kept alive. Similarly, some of the derelict, dilapidated, massive warehouses through which flowed so much trade are being given a new lease of life as restaurants.

Some things, of course, can never be revived: the various hawkers with their distinctive signature calls (the laksa man, the kling-tong man or the ting-tin man, so-called because of the noise he made with the artefact he carried), the walking haberdashery man, the foodsellers, the cloth vendors, the satay

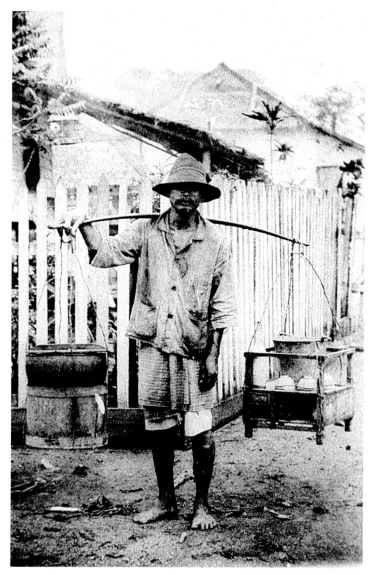

26. Hawker, *c.* 1900. Courtesy National Archives of Singapore.

man, and the ice ball man (who sold ice shavings scraped into a ball on to which was poured rose syrup). They are part of a landscape whose sounds and sights and smells were rich with the aroma and flavour of history and ethnicity. The old has necessarily and practically given way to the new but the memories remain, in tapes and photographs and words, to be pored over with nostalgia (Plate 26).

Singapore today can perhaps best be summed up by the words of Iris Miller, Professor and noted American architecture landscape and urban design consultant, who visited the city-state in 1989: 'The stunning mix of old and new architecture, set in a bustling and urban environment, immediately alerts one to Singapore's position as a vital economic leader among the communities of the Pacific Rim. While the image of a modern cosmopolitan society—based upon technology, trade, and the work ethic—is readily perceived, its history as the confluence of numerous cultures is foretold in a range of building forms. From the vernacular architecture of colourful rows of low-slung shop houses of Chinatown and Little India at Serangoon Road to the contrasting shiny high-tech materials of tall contemporary office and apartment blocks, Singapore is an archive of rich urban memory, instantly inviting the viewer to observe its transformation through time.'

Select Bibliography

Abdullah bin Kadir, *The Hikayat Abdullah: The Autobiography of Abdullah bin Kadir (1797–1854)*, annotated translation by A. H. Hill, Singapore, Oxford University Press, 1969.

Beamish, Jane and Ferguson, Jane, *A History of Singapore Architecture*, Singapore, Graham Brash, 1985.

Begbie, P. J., *The Malayan Peninsula*, Madras, Vespery Mission Press, 1834; reprinted Kuala Lumpur, Oxford University Press, 1967.

'Bengal Civilian' (Charles Walter Kinloch), *Rambles in Java and the Straits in 1852*, London, Simpkin, Marshall and Co., 1853; reprinted Singapore, Oxford University Press, 1987.

Bickmore, Albert S., *Travels in the East Indian Archipelago*, London, J. Murray, 1868; reprinted Singapore, Oxford University Press, 1991.

Bird, Isabella L., *The Golden Chersonese and the Way Thither*, London, J. Murray, 1883; reprinted Kuala Lumpur, Oxford University Press, 1967, and Singapore, Oxford University Press, 1990.

Bleackley, Horace, *A Tour in Southern Asia (1925–1926)*, London, John Lane The Bodley Head Limited, 1928.

Braddell, Roland, *The Lights of Singapore*, Methuan & Co. Ltd., 1934; reprinted Kuala Lumpur, Oxford University Press, 1982.

Brown, Edwin A., *Indiscreet Memories*, London, Kelly & Walsh Ltd., 1935.

Buckley, Charles Burton, *An Anecdotal History of Old Times in Singapore 1819–1867*, 2 vols., Singapore, Fraser & Neave, 1902; reprinted Kuala Lumpur, University of Malaya Press, 1965, and Singapore, Oxford University Press, 1984.

Caine, W. S., *A Trip Round the World in 1887–8*, London, George Routledge and Sons, 1888.

Cameron, Charlotte, *Wanderings in South-Eastern Seas*, London, T. Fisher Unwin Ltd., 1924.

Cameron, John, *Our Tropical Possessions in Malayan India*, London, Smith, Elder & Co., 1865; reprinted Kuala Lumpur, Oxford University Press, 1965.

Candee, Helen Churchill, *New Journeys in Old Asia: Vignettes of Indo-*

China, Siam, Java and Bali, New York, Fredrick A. Stokes Company, 1927.

Cheo Kim Ban, *A Baba Wedding*, Singapore, Eastern Universities Press Sdn. Bhd., 1983.

Crawfurd, J., *History of the Indian Archipelago*, Archibald Constable and Co., Edinburgh, 1820.

————, *Journal of an Embassy from the Governor-General of India to the Courts of Siam and Cochin China*, London, Henry Colburn, 1828; reprinted Kuala Lumpur, Oxford University Press, 1967, and Singapore, Oxford University Press, 1987.

Din, *Singapore Jottings*, Singapore, Koh Yew Hean Press, 1885.

Earl, George Windsor, *The Eastern Seas, or Voyages and Adventures in the Indian Archipelago in 1832–33–34*, London, W. H. Allen & Co., 1837; reprinted Singapore, Oxford University Press, 1971.

Edwards, Norman and Keys, Peter, *Singapore: A Guide to Buildings, Streets, Places*, Singapore, Times Books International, 1988.

Foran, W. Robert, *Malayan Symphony*, London, Hutchinson and Co., 1935.

Geylang Serai: Down Memory Lane: Kenangan Abadi, Singapore, Heinemann Publishers Asia Pte. Ltd. and National Archives of Singapore, 1986.

Hattendorf, John B., *The Two Beginnings: A History of St. George's Church, Tanglin*, Singapore, 1984.

Hill, Gibson C. A., 'Indonesian Trading Boats', *Journal of the Malayan Branch of the Royal Asiatic Society*, Vol. XXIII, Pt. 1, 1950.

Hornaday, William T., *Two Years in the Jungle: The Experiences of a Hunter and Naturalist in India, Ceylon, the Malay Peninsula and Borneo*, New York, Charles Scribner's Sons, 1885.

Innes, Emily, *The Chersonese With the Gilding Off*, 2 vols., London, Richard Bentley and Son, 1885; reprinted in 1 vol., Kuala Lumpur, Oxford University Press, 1974.

Keaughran, T. J., *Picturesque and Busy Singapore*, Singapore, Lat Pau Press, 1857.

Land Transport of Singapore from Early Times to the Present, Singapore, Archives and Oral History Department, June 1984.

Lee Kip Lim, *The Singapore House 1819–1942*, Singapore, Times Editions and Preservation of Monuments Board, 1988.

Levien, Michael (ed.), *The Cree Journals*, Exeter, England, Webb & Bower, 1981.

Li, Tania, *Malays in Singapore: Culture, Economy and Ideology*,

Singapore, Oxford University Press, 1989.

Makepeace, W., Brooke, G. E., and Braddell, R. St. J. (eds.), *One Hundred Years of Singapore*, 2 vols., London, John Murray, 1921; reprinted Singapore, Oxford University Press, 1992.

McKie, R. C. H., *This was Singapore*, Sydney, Angus and Robertson, 1942.

McNair, John F. A., *Prisoners Their Own Warders*, Westminster, A. Constable, 1899.

Miksic, John N., *Archaeological Research on the 'Forbidden Hill' of Singapore: Excavations at Fort Canning, 1984*, Singapore, National Museum, 1985.

Moore, Donald and Moore, Joanna, *The First 150 Years of Singapore*, Singapore, Donald Moore Press Ltd. in association with the Singapore International Chamber of Commerce, 1969.

Nahuijs, Colonel, 'Extracts from the Letters of Col. Nahuijs', *Journal of the Malayan Branch of the Royal Asiatic Society*, Vol. XIX, Pt. 11, 1941.

Nathan, Eze, *The History of Jews in Singapore 1830–1945*, Singapore, Herbilu Editorial & Marketing Services, 1986.

Norris, George, *Singapore 30 Years Ago*, Straits Times Press, 1878.

North, Marianne, *A Vision of Eden: The Life and Work of Marianne North*, Exeter, Webb & Bower, and the Royal Botanic Gardens, Kew, 1980.

Pearson, H. F., *Journal of the Malayan Branch of the Royal Asiatic Society*, Vol. XXV, Pt. 1, 1952.

Pedersen, Hugo V., *Door Den Oost-Indischen Archipel*, Haarlem, H. D. Tjeenk Willink & Zoon, 1902.

Peet, George L., *Rikshaw Reporter*, Singapore, Eastern Universities Press Sdn. Bhd., 1985.

Pratt, Ambrose, *Magical Malaya*, Melbourne, Robertson & Mullens Ltd., 1931.

Quahe, Yvonne, *We Remember*, Singapore, Landmark Books Pte. Ltd., 1986.

Rathborne, Ambrose B., *Camping and Tramping in Malaya*, London, Swan Sonnenschein & Co., 1898; reprinted Singapore, Oxford University Press, 1984.

Reith, G. M., *Handbook to Singapore*, Singapore, Fraser and Neave Ltd., 1892; reprinted Singapore, Oxford University Press, 1985.

Ross, John Dill, *Sixty Years of Life and Adventure in the Far East*, London, Hutchinson & Co., 1911.

Sharp, Ilsa, *The Singapore Cricket Club, 1852–1985*, Singapore, The Singapore Cricket Club, 1985.

Sherry, Norman, *Conrad's Eastern World*, London, Cambridge University Press, 1966.

Siddique, Sharon and Nirmala Puru Shotam, *Singapore's Little India, Past, Present and Future*, Singapore, Institute of Southeast Asian Studies, 1982.

Song Ong Siang, *One Hundred Years' History of the Chinese in Singapore*, London, John Murray, 1902; reprinted Kuala Lumpur, University of Malaya Press, 1967, and Singapore, Oxford University Press, 1984.

Tinsley, Bonnie, *Visions of Delight*, Singapore, Singapore Botanic Gardens, 1989.

Thomson, John Turnbull, *Some Glimpses Into Life in Malayan Lands*, London, Richardson & Co., 1864; reprinted Singapore, Oxford University Press, 1984 and 1991.

Turnbull, C. M., *A History of Singapore 1819–1975*, Kuala Lumpur, Oxford University Press, 1977; 2nd edn. Singapore, Oxford University Press, 1989.

Tyres, Ray, *Singapore Then and Now*, Singapore, Universities Education Press, 1975.

Van Cuylenburg, John Bertram, *Singapore Through Sunshine and Shadow*, Singapore, Heinemann Asia, 1982.

Wallace, Alfred Russel, *The Malay Archipelago*, London, Macmillan & Company, 1869; reprinted Singapore, Oxford University Press, 1986.

Warren, James Francis, *Rikshaw Coolie: A Peoples' History of Singapore (1880–1940)*, Singapore, Oxford University Press, 1986.

Wilkes, Charles, *The Singapore Chapter of the Narrative of the United States Exploring Expedition During the Years 1838, 1839, 1840, 1841, 1842*, Philadelphia, Lea and Blanchard, 1845; reprinted Singapore, Antiques of the Orient Pte. Ltd., 1984.

Wise, Michael with Mun Him Wise (compilers), *Travellers' Tales of Old Singapore*, Singapore, Times Books International, 1985.

Wright, Arnold and Cartwright, H. A. (eds.), *Twentieth Century Impressions of British Malaya*, London, Lloyds Greater British Publishing Co. Ltd., 1908; abridged edn. reprinted Singapore, Graham Brash Pte. Ltd., 1989.

Wright, Arnold and Reid, Thomas H., *The Malay Peninsula: A Record of British Progress in the Middle East*, London, T. Fisher Unwin, 1912.

Wurtzburg, C. E., *Raffles of the Eastern Isles*, London, Hodder & Stoughton, 1954; reprinted Singapore, Oxford University Press, 1984.

Yen Ching-hwang, *A Social History of the Chinese in Singapore and Malaya 1800–1911*, Singapore, Oxford University Press, 1986.

Yule, Henry and Burnell, A. C., *Hobson-Jobson: A Glossary of Anglo-Indian Colloquial Words and Phrases and of Kindred Terms*, 1903; 2nd edn. New Delhi, Munshiram Manoharlal Publishers, 1979.

Yvan, Melchior, *Six Months among the Malays and a Year in China*, London, James Blackwood, 1855.

Index

References in brackets refer to Plate numbers; those in brackets and italics to Colour Plate numbers.

Albert Street, 18
Alexandra Road (Lau Chi Ka), 19
Anglo-Dutch Treaty, 29
Angsana, 23, 24, 26
Arabs: dress, 33, 46, (9); early immigrants, 8, 45; well-known families, 45, 46, (14)
Armenians: Church, 27, 46; early immigrants, 8, 46; street names, 17; vocations, 46, 48; well-known families, 46, 48
Artillery Avenue, 18
Atap, 15, 42

Babas, 54, (18)
Bali Lane, 19
Bangsawan, 45, 75
Beach Road, 29
Begbie, P. J., 33
Bencoolen, 15, 29; Street, 19
'Bengal Civilian' (Charles Walter Kinloch), 25
Bird, Isabella, 26, 41
Bleackley, Horace, 30
Boat Quay, 11, 19
Botanical Gardens, 16, 21, 23, 74, 75, (7)
Braddell, 37
Bras Basah Road, 18, 29
Bridges: Anderson, 30; Cavenagh, 23, 30, 72; Elgin, 30, 31, 67; Ord, 30; Read, 30
Brown, Edwin, A., 57
Buckley, Charles Burton, 61, 65
Buffalo, *see* Bullock

Bugis, 7, 43, 45; Street, 19
Bukit Merah, 20
Bukit Timah, 18, 20, 21, 65
Bullock, 57, 58; cart, 71, (19)
Bungalow, 36, 37, 42
Buses, 67

Caine, W. S., 40
Cairnhill, 19
Cameron, Charlotte, 31, 51, 71
Cameron, John, 8, 11, 16, 44, 67
Candee, Helen, 33
Canning, Viscount, 13
Cannonball tree, 24
Cantonment, 7
Cathedral of the Good Shepherd, 69
Cheo Kim Ban, 54
Chettiar Road, 19
China Street (Kian Keng Chen), 19
Chinatown, 51, 58
Chinese: boats, 31, 49, 67; coolies, 32, (9); dress, 33, (9); early immigrants, 48, 49; festivals, 50, 51; Gardens, 74; life-style, 50, 51; maidens, 60; opera, 75; residences, 37; settlements, 7, 11, 24, 50; shophouse, 50; temples, 29, 50, 69, (14); vocations, 49; well-known personalities, 51, 54
Chong Hong Lim Street, 17
Chulia Road, 19
Church Street, 19
City Hall, 25, 27
Clubs: Cricket, 58, 72, 74; Ladies' Lawn Tennis, 23; Tanglin, 72, 74

Coleman, 8, 26, 27, 46; Street, 17
College Road, *see* Bras Basah Road
Collyer Quay, 23, 72
Commercial Square, 5, 8, 11, 19, 30, 46, (4)
Connaught Drive, 26
Conrad, Joseph, 27, 29
Corintin, 24
Court House, 27, (8)
Crawfurd, John, 13, 15
Cree, Edward H., 51
Cricket, 41

D'Almeida Street, 17
Daddy Abrams, 59, 60
Dalhousie Memorial, 72
Dhobi, 18, (6)
Dhobi Green, 18, 23
Dikir barat, 75
Durrell, Lawrence, 33
Dutch, 4, 5; Governor, 6

Earl, George Windsor, 15, 58
East India Company, 4, 5
Eliot, T. S., 68
Empress: Hall, 29; Place, 72
Esplanade, 23, 25, 41; Drive (Connaught), 26
Eurasians: early immigrants, 48; life-style, 48; street names, 17; vocations, 48
Europeans: amusements, 41; dress, 33, 34, (9), (10), (11); exercise, 41; houses, 16, 37; life-style, 37, 38, 39, 40; women, 60

Farquhar, Colonel, 5, 6, 7, 8, 15
Fire Brigade, 60, 65
Five-foot ways, 11
Fives Court, 41
Flame of the Forest, 11
Flanders Road, 17
Foran, W. Robert, 49

Fort Canning Hill, 2, 13, 14, 15, 16, 23, 37, 38, 41, 69, 74
Fort Road, 17
Fruit, 40, (12)

Gallop Road, 24
General Hospital, 7, 29
Geylang, 43, 65; Road, 23
Gissing, George, 57
Glam tree, 7
Godowns, 8, 11, 40, (2)
Gopuram, 29, 69
Government Hill, *see* Fort Canning Hill
Government House, 23, 71

Hastings, 4, 6
Havelock Road (Masak Arak Sadakku), 19
Hawkers, 75, (26)
Hindu Road, 19
Hobson-Jobson, 7, 37
Hokkien Street (Cho Be Chia Koi), 19
Hoo Ah Kay, 51, (17)
Hornaday, William, 6, 18
Horse carriage, 59, 60, (20)
Hotels: de l'Europe, 27, 74; Goodwood Park, 71, 72; Raffles, 48, 71, (10); Oranje, 48

India, 45, 48
Indians: appearance, 55; boats, 67; convicts, 29, 30, 38; cuisine, 56; dress, 33; early immigrants, 8, 54, 69; festivals, 56; Hindu temples, 29, 69; life-style, 56; Muslims, 45, 46; people, 67, (11); settlements, 8; women, 60
Innes, Emily, 55
Iskandar Syah, 1, 14; *kramat* of, 2, (5)
Istana, *see* Government House

Jackson, Lieutenant, 8

Japanese: Gardens, 74; Occupation, 25; War Criminals trials, 72

Jews: dress, 48; early immigrants, 48; street names, 17; synagogues, 48, 49, (15); well-known personalities—Manasseh brothers, 72; Manasseh Meyer, 48

Jinriksha, *see* Riksha

John Little, 20, 46

Johor, Temenggong of, 4, 5, 6, 7, 8, 43

Junks: Chinese, 31, 49; Siamese, 31, (7)

Kadir, Abdullah, *see* The Hikayat Abdullah

Kajang, 4, 24

Kallang, 18

Kampongs: Glam, 7, 43; Roko, 18; Tempe, 18

Kayu puteh, *see* Glam tree

Kereta Ayer, *see* Chinatown

Klings, *see* Indians

Lavender Hill, 20

Macpherson, Ronald, 26

Madjapahits, 2

Madras *chunam*, 30

Makepeace, W., 4

Malabar Hotel, *see* Hotel de l'Europe

Malan, Major C. H., 71

Malays: amusements, 43, 44, 45; boats, 31, 67; dress, 33; house, 15, 42, (9); people, 43, (13); religion, 45; settlements, 24, 42, 43; village, 45, (9); women, 44, 60

Mango, 40

Mangrove, 2, 24, (1)

Markets, 31

Marsden, William, 6, 15

Mass Rapid Transit System (MRT), 67

Maxwell, John Argyll, 27

Ma-Zu-Po, 68

McKie, R. C. H., 43

McNair, Major John, 29, 71

Miksic, John, 13

Miller, Iris, 77

Moore, Donald and Joanna, 6, 48

Mosque Street, 19

Mosques, 46, 69, (24)

Motor cars, 65

Munshi Abdullah, *see* The Hikayat Abdullah

Nahuijs, Colonel, 16

National Museum, 27, 71, (16)

Nibong, 24, 42

Orang Laut, 2, 4, 42, 43

Orchard Road, 19, 23, 65

Oxley, Dr Thomas, 21, 60

Oxley Road, 19

Padang, 7, 15, 16, 24, 25, 74, (4)

Pagoda Street, 19, 69

Panisi, 7

Parameswara, *see* Iskandar Syah

Parliament House, 27

Pearson, H. F., 15

Peet, George L., 24

Piracy, 5

Portuguese, 2

Prinsep, 19, 71

Punkas, 37

Pulao Bukom, 19, 58

Racecourse, (8)

Racing, 41

Raffles: City, 29; Institution, 27, (5); Library and Museum, 23; Place, *see* Commercial Square

Raffles, Thomas Stamford: birth, 2; career, 1, 4, 5, 6; house, 15, 16, 17, 36; statue of, 23, 26, 29, 72, (1)

Rain tree, 26
Regatta, 43
Reith, G. M., 23
Revere, Maria, 27
Riau, 2, 43
Ridley, 74
Riksha, 61, 62, 63, (21); station, 31
Ross, John Dill, 38, 60
Rowse, A. L., 17

Sago: Lane, 19; Street, 19
Sampan, 31, 67
Scandal Point, 25
Scott, 19
Screwpine, 24
Sea Gypsies, *see* Orang Laut
Sejarah Melayu, 1, 45
Sepoy Lines, 7
Shanghai jar, 38
Singapore: founding, 5; history of, 1;
 maps, (2), (3), endpapers; modern
 city, 68; origin of name, 1;
 planning of, 6, 7, 8, 11; railway,
 65, (13)
Singapore Electric Tramways
 Company, 63, (22)
Singapore Free Press, 11, 49, 58, 62
Singapore River, 4, 5, 6, 7, 8, 23, 30,
 42, 67, 72, (6), (23)
Somme Street, 17
South Bridge Road (Kalapithi Kadei
 Sadakku), 19
Spaniards, 6
Sri Tri Buana, 1, 14
Stamford Road, 29
St. Andrew's Church, 26, (3)
St. Andrew's Road, 26
St. Gregory's Church, *see* Armenian
 Church
Sultan Mosque, *see* Mosques
Swamp, (1), 2
Syce, 60, (12)
Synagogue Street, 19

Tan Kim Seng fountain, 72, (25)
Tan Yeok Nee, 29; house, 54
Tanglin Barracks, 69, (15)
Tanjong Katong Park, 17
Tanjong Pagar: Dock Company, 63;
 docks, 31; riksha station, 63; Road,
 32; shophouses, 68, 75
Tao Nan School, 71
Telok Ayer, 50, 69; market, 31
Telok Blangah, 8, 43, 65
Tembusu, 24
Tengku Long, 5
Teutonia Club, *see* Hotels,
 Goodwood Park
Thamby, 40
The Forbidden Spring, 13
The Gap, 20
The Hikayat Abdullah, 4, 5, 15, 57
The Plain, *see* Padang
Thomson, John Turnbull, 24, 48, 72
Thomson: Reservoir, 21, 23; Road,
 17
Thong Chai Medical Hall, 29, 68
Tome Pires, 1
Tongkang, 31, 67
Topee, 33, (10)
Traveller's Palm, 21
Tumasik, 1, 2

Verdun Street, 17
Victoria Street (Rochore Road), 18,
 29
Victoria Theatre, 27, 29, 75

Wallace, Alfred Russel, 68
Wallich, Nathaniel, 16
Wallich Road (Cursetjee Street), 20
Wang Da-Yuan, 1
Warren, James Francis, 61, 65
Waterloo Street, 17
Wayang, 51, 52, (16)
Whampoa, *see* Hoo Ah Kay
Wilkes, Charles, 31, 51, 54, 56

Willan, William A., 69
Woodlands, 23
Wright, Arnold and Cartwright,
 H. A., 20, 45, 71
Wright, Arnold and Reid, Thomas
 H., 21

Yvan, Melchior, 59

Zheng He, 1
Zion Road, 19

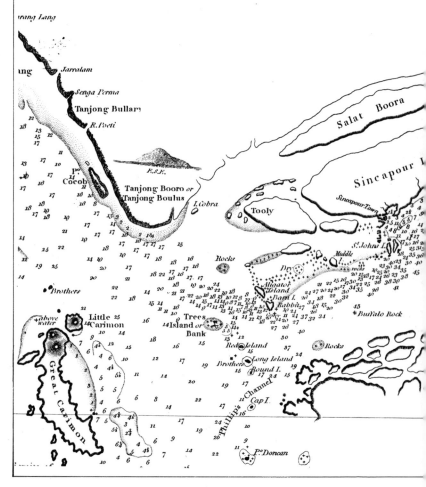

James Horsburg's Chart of the Straits of Malacca, 1823, showing the entrance to the Singapore River with surroundings discovered as a result of Raffles' landing in 1819.